DUCCIO
and the Origins of Western Painting

Keith Christiansen

The Metropolitan Museum of Art, New York
Yale University Press, New Haven and London

Director's Note

Much has been written about the purchase, in 2004, for a very large sum of money, of Duccio's *Madonna and Child*, so knowledgeably discussed in the pages of this *Bulletin* by Curator Keith Christiansen, and much said about the process of the acquisition itself.

It has been reported that upon seeing the picture in London with Keith and Paintings Conservator Dorothy Mahon I made an offer on the spot. This is true: there was need for a quick decision, as other institutions were also seriously considering the Duccio. In this brief note I wish simply to correct the misleading impression that in making an acquisition of this importance and expense, it was my response to the picture's quality and art historical significance and my confidence in that response that was the determinative factor. Unquestionably, I sensed in the Duccio *Madonna and Child* that quality of transcendence that emanates from a truly consummate masterpiece. But recommending so large an expenditure to our Acquisitions Committee required more than just my response—the response of one not an expert in early Italian painting. It required that this response be reinforced by the assurance that comes from the trust I have learned to place in the curators and conservators in this great institution. Not only are Everett Fahy, John Pope-Hennessy Chairman of the Department of European Paintings, and Keith Christiansen authorities on the period, but their eye for quality has been repeatedly tested and borne out by a record of wonderful acquisitions.

As I held the picture in my hands, enraptured by its human quality, the brilliance of the paint surface and the luminous gold ground, the refinement of the drawing, and the tenderness of the Child's gesture toward his mother, I was treated all the while to Keith's impassioned scholarship and his explanation of the importance of the painted parapet and the place of the work in the oeuvre of the artist and the development of Western painting. My love for the Duccio may have been founded on fairly good instincts, but it provided no more than a sense that the picture would be a highly desirable acquisition; it was particularly Keith's precise and learned assessment of the picture that allowed me to consider the acquisition an imperative.

Philippe de Montebello, *Director*

Reprint of *The Metropolitan Museum of Art Bulletin* (Summer 2008). Copyright © 2008 by The Metropolitan Museum of Art, New York.

This publication was made possible through the generosity of the Lila Acheson Wallace Fund for The Metropolitan Museum of Art, established by the cofounder of *Reader's Digest*.

Additional support has been provided by The Peter Jay Sharp Foundation.

Publisher and Editor in Chief: John P. O'Neill
Editor of the *Bulletin*: Sue Potter
Production: Christopher Zichello
Design: Bruce Campbell

On the cover: Duccio di Buoninsegna (active by 1278, died 1318). *Maestà*, 1308–11 (detail of front panel; see fig. 1)

Cataloging-in-Publication data is available from the Library of Congress.
ISBN: 978-1-58839-289-3 (The Metropolitan Museum of Art)
ISBN: 978-0-300-14544-1 (Yale University Press)

Printed and bound in Singapore.

Foreword

On the morning of September 24, 2004, I met the Director of the Museum, Philippe de Montebello, and a member of our conservation staff, Dorothy Mahon, at Newark International Airport to board a day flight to London to examine a possible acquisition. This was anything but business as usual. In the normal course of events, an object is sent to the Museum for examination and eventual presentation before the Acquisitions Committee, composed of members of the Board of Trustees. But the circumstances that pertained in this case were exceptional, from every standpoint. Earlier that summer Everett Fahy, John Pope-Hennessy Chairman of the Department of European Paintings, and I had been made aware that an extremely rare and beautiful *Madonna and Child* (see fig. 36) by the great late medieval Sienese painter Duccio di Buoninsegna was being sold privately through the auction house of Christie's. I knew the picture from old black and white photographs in books on Sienese painting and the two principal monographs on Duccio. Indeed, I had made a passing reference to it in my doctoral thesis (later published as a monograph) on Gentile da Fabriano. There are few works of art I longed to see more than this small but astonishing picture, which following the deaths in 1949 of the discerning collector Adolphe Stoclet and his wife, Suzanne, had become inaccessible to most scholars. Negotiations to include the picture in the landmark exhibition on Duccio and his followers that was held in Siena in 2003 had broken down, and the work appeared merely as an illustration in the catalogue—astonishingly, this was the first time it had been reproduced in color! The picture would have been at the top of anyone's wish list for acquisition, and in fact it was known that the Louvre was also interested in its purchase since, remarkably enough, it too had no work by the artist.

In 1911 the Metropolitan had been so fortunate as to acquire from a British collection a panel by Duccio's somewhat younger contemporary Giotto, who is usually credited as the founder of modern European painting, but for some reason it had missed out on the few works by Duccio that had come on the market—the predella panel from the *Maestà* sold to the Frick Collection in 1927 (see fig. 21); two further predella panels acquired by Andrew W. Mellon and Samuel H. Kress and now in the National Gallery of Art, Washington, D.C.; and the exquisite triptych purchased in 1945 by the Museum of Fine Arts in Boston (see fig. 39)—all handled by the legendary firm of Duveen. The Museum had even passed over the two admittedly somewhat damaged panels from the Rockefeller collection that were sold, respectively, to Baron Thyssen-Bornemisza in 1971 and the Kimbell Art Museum in 1975. In retrospect this seems incomprehensible, for it is not possible to tell the story of fourteenth-century Italian art, and thus of the beginnings of Western painting, without Duccio. The Stoclet panel was the last work by the artist still in private hands, so it is not surprising that when I showed the transparency I had received to the Director when he returned from his vacation, he immediately saw the unique opportunity to redeem our sins of omission.

As no technical analysis of the picture had ever been undertaken, Dorothy Mahon and I prepared ourselves by carefully checking the two existing photographs of the picture, taken at different stages in its history, and examining under magnification the very good transparency we had been given by Christie's. We then made a list of those technical issues to which special attention needed to be directed. We brought along a magnifier and an ultraviolet lamp, a standard device used to identify retouches and restorations.

In London the next morning, following a good night's rest, the three of us walked over to Christie's, on King Street, where we were met and taken to a private, sun-filled viewing room. Left alone, we turned our attention to the little picture, which was propped on

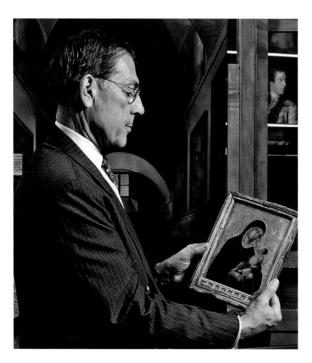

Philippe de Montebello looking at Duccio's *Madonna and Child*

a small easel. Like a poem or a piece of music, a great work of art—even a very small one—has the power to cast a spell over susceptible viewers, to draw them into the world of its creator. For a few moments we were silent, each of us registering our impressions. Ever since, almost forty years ago, I first stood before the *Maestà* in the Museo dell'Opera del Duomo in Siena, I have been haunted by Duccio's singular gift for suggesting an ineffable, sacred presence in his depictions of the Virgin and Child, and it is this quality that first struck me—except that in this small picture there is an intimacy in the relation of mother to child that is quite different from what one finds in the artist's public altarpieces, and the face of the Virgin is touched by a haunting melancholy even more poignant than I remembered from his larger, public paintings. Remarkably, even when seen from a distance the picture managed to convey its qualities. We took turns taking in its details before Dorothy set about her all-important task of examining the picture centimeter by centimeter to assess its condition. I occupied myself making some record photographs of the edges and reverse side of the panel. The question of whether it was an independent panel or one wing of a portable diptych was quickly answered: there were no marks of hinges, and the panel was complete, even retaining its original frame, with its edges painted red as was common practice in the fourteenth century. The picture proved to be well preserved, and we were all in agreement that it was of exceptional power and beauty: a transformative work of art.

We spent about two hours with the picture before calling the Christie's representatives back into the room. I imagined that we were now about to embark on drawn-out discussions and negotiations, with intense competition from other institutions. This assumption proved dead wrong. The Director seized the initiative and stated that he was prepared to make an offer for the painting. I don't know who was more taken aback, the Christie's representatives or Dorothy and I. Christie's was acting on behalf of the owners, who would need to be notified. As a matter of course there would be further negotiations, but the gears had been set in motion, and it seemed to me that the picture was now destined for the Metropolitan Museum.

As we still had an hour or so before our return trip, we decided to walk the few blocks to the National Gallery, which owns a portable triptych by Duccio (see fig. 38) that has long been a cornerstone of its superb collection of early Italian paintings. The triptych is a work of extraordinary beauty and impeccable craftsmanship. Duccio struck a slightly different key than in the picture we had been examining, placing greater emphasis on the regal bearing of the Virgin. The motif of the Child playing with his mother's veil is further developed, so that Christ unfurls a rich cascade of folds. But these enhancements came at the expense of the simple dignity and touching humanity of the small panel we had seen at Christie's. In short, we felt that we had before us the opportunity of acquiring a painting that was on a par with one of Duccio's most admired and best-preserved works, a painting that represented the artist at the very height of his powers.

On the return flight I noticed that the Director was bent over a list of what seemed to be the various funds that might be applied to the purchase of the picture. "You must have worked out the mechanics for this even before we left to examine the picture," I observed. "Oh yes, this trip was to confirm that the picture was as extraordinary as it already seemed to me, and if it was, I had determined we were going to get it." Trustees still needed to be

consulted and further funds identified, and weeks were to pass before a final deed of sale was signed. But the key step had been taken. In October our expert extraordinaire on panel paintings, George Bisacca, went to London to pack the picture and hand carry it back to New York. George is an ardent student of Italian art and has worked on numerous early Italian paintings and knows their idiosyncrasies as well as anyone in the world, so I asked him to be sure to call me from London with his reaction. When he did so, I could tell from the tone of his voice that he shared our enthusiasm. Indeed, he could hardly believe that we had managed to secure an object of this quality and preservation.

Since that time the picture has been further examined. Pigment samples have been taken to identify the blue (azurite), the underdrawing—typical of the artist—has been recorded with infrared reflectography, and an X-ray has also been made. Daniele Rossi, the Florentine restorer who had worked most recently on the panels of the *Maestà* in Siena, was invited to examine the panel and share his knowledge of Duccio's technique. I published the results of these examinations in an article in *Apollo* in February 2007.

Although Duccio has long been recognized as the father of Sienese painting, in textbooks his very considerable contribution to European painting has often been overshadowed by that of Giotto, who was unquestionably the outstanding Italian artist prior to Masaccio and one of the great innovators of all time. We might compare the connection between Giotto and Duccio to the relationship between Michelangelo and Raphael, or between Picasso and Matisse. This *Bulletin* attempts to explain those particular qualities that make Duccio such an essential artist. It is dedicated to Philippe de Montebello, whose decisive action brought this jewel into the collection of The Metropolitan Museum of Art.

Keith Christiansen, *Jayne Wrightsman Curator of European Paintings*

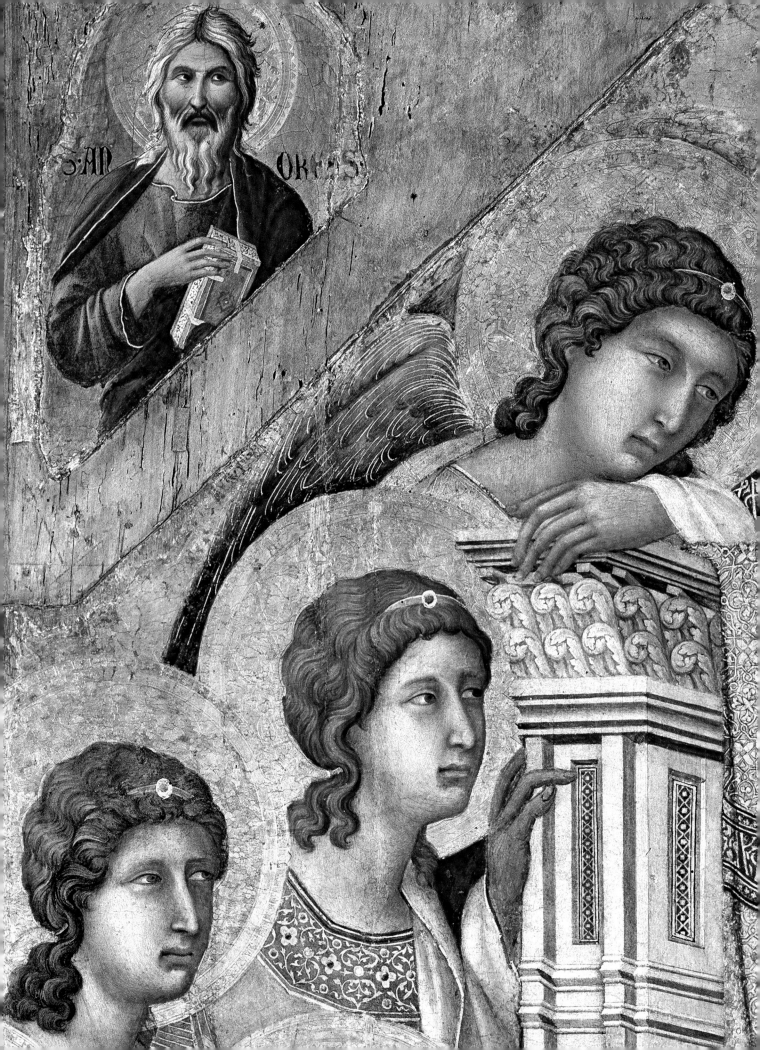

Duccio and the Origins of Western Painting

Keith Christiansen

O n June 9, 1311, the shopkeepers of Siena latched the shutters of their stalls. Trade stopped, and the citizens decked out their windows with whatever decorative hangings they possessed. The governors of the city—the Council of the Nine, or the *Nove*, as they were known—hired trumpeters, pipers, and castanet players, while the churches made sure someone was on hand to ring bells. The occasion was the completion of a massive double-sided altarpiece some fifteen feet tall and more than sixteen feet wide for the high altar of the cathedral, located in the apse, just beyond the domed crossing. Propped on a large cart, it was processed around the central square of the city, the Piazza del Campo, and then to the cathedral, where it was possibly the second replacement for a venerable, early thirteenth-century image of the Madonna and Child and became the backdrop for religious and civic celebrations. The truly enormous sum of 3,000 florins had reportedly been spent for this grandest of all medieval altarpieces, painted by Duccio di Buoninsegna (active by 1278, died 1318), who had attained a position of prominence in Italy surpassed only by his somewhat younger Florentine contemporary Giotto (1266/67–1337).

The work in question, one of the keystones of Western painting, is familiar to visitors to Siena, where its main components are displayed in the Museo dell'Opera del Duomo. On the altarpiece's front face (fig. 1) is the Virgin enthroned in majesty—hence the name *Maestà* (Majesty) by which the image is commonly known. She is accompanied by a court of ten saints and twenty angels, four of whom gaze, with hauntingly longing expressions, over the back of an elaborate marble throne decorated with a richly patterned fabric. The four kneeling saints in the foreground—Ansanus, Savinus, Crescentius, and Victor—were the patrons of Siena. Their heads are turned toward the Virgin, and each extends one hand in supplication. When the altarpiece was intact (see fig. 2), below this magnificent, richly colored image was a base, or predella, with scenes from the life of Christ, and above it was a series of pinnacles in which were depicted episodes from the last days of the Virgin's life and of her Assumption. The pinnacles were in turn crowned by a series of bust-length angels. On the reverse side (figs. 3 and 4) were more than forty scenes representing episodes from Christ's life and his miraculous appearances following his death: scenes that allowed the artist to demonstrate to the fullest his skill as a narrative painter and his mastery of the representation of landscape settings, urban vistas, and interiors populated by figures involved in an almost bewildering variety of situations. Quite apart from its importance as a liturgical object, the altarpiece offered an encyclopedia of artistic accomplishment and served as the point of departure for generations of Sienese painters. Aside from Giotto's famous fresco cycle in the Arena Chapel in Padua, there really was nothing comparable.

Even today, the various pieces of the *Maestà* on view in the Museo dell'Opera del Duomo leave an indelible impression. (The front and back were separated in 1777 and the pinnacles and predella disassembled; some of the individual narrative scenes were subsequently sold.) So imagine the effect when this magnificent altarpiece was installed on the

Opposite: Duccio di Buoninsegna (active by 1278, died 1318). Detail from the front panel of the *Maestà* (fig. 1)

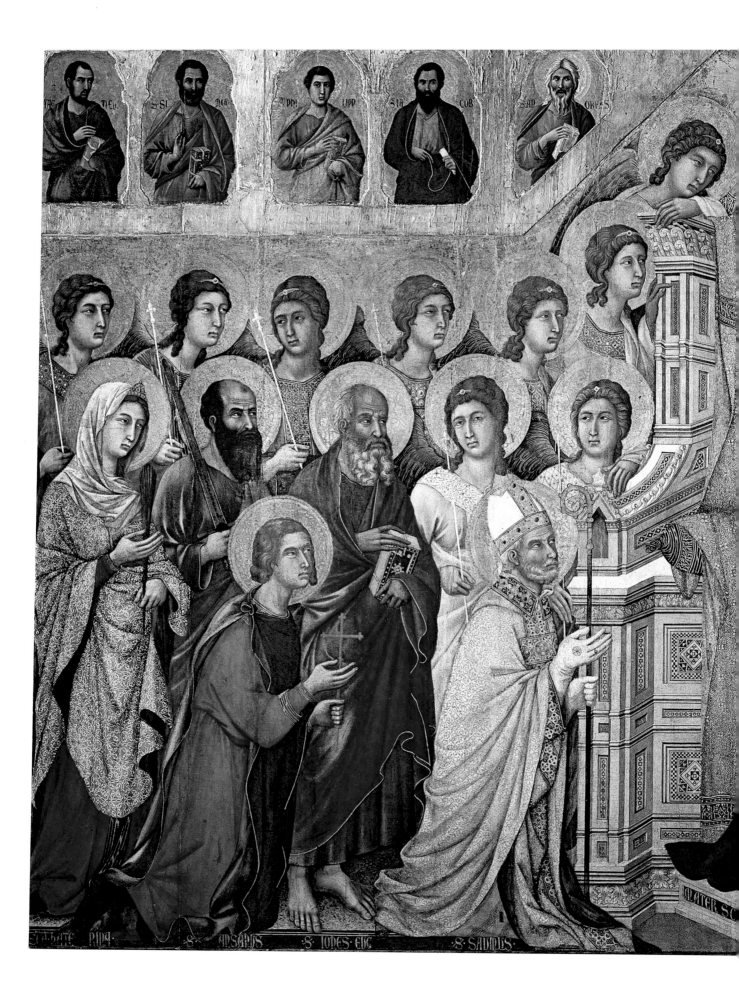

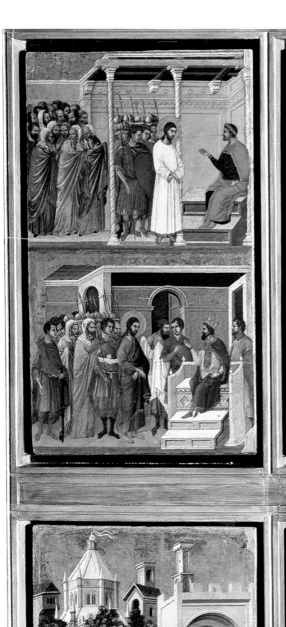
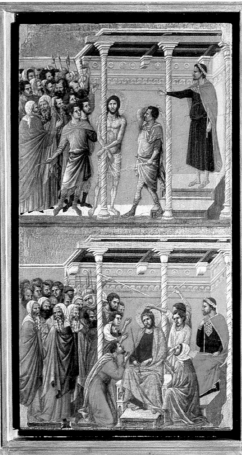
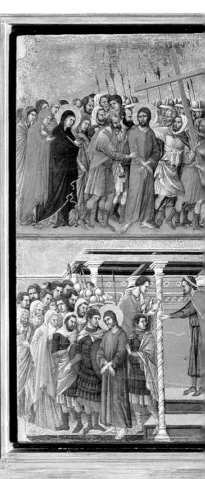
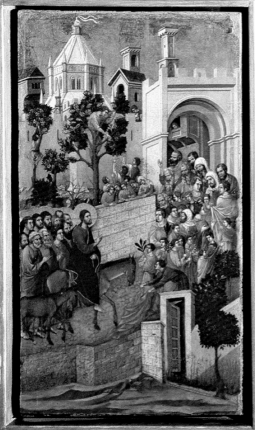
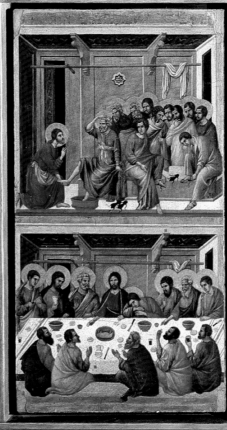
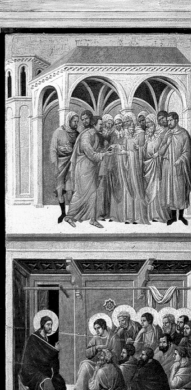

1. Duccio di Buoninsegna (active by 1278, died 1318). *Maestà* (front panel), 1308–11. Gold and tempera on wood, 12 ft. 1⅝ in. x 14 ft. 9⅛ in. (3.7 x 4.5 m). Museo dell'Opera del Duomo, Siena

2. Photomontage of the front of Duccio's *Maestà* (fig. 1)

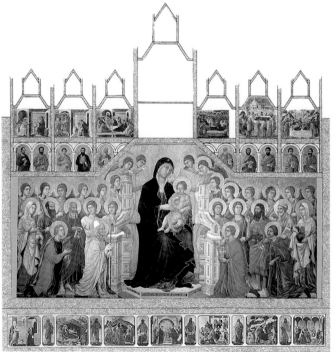

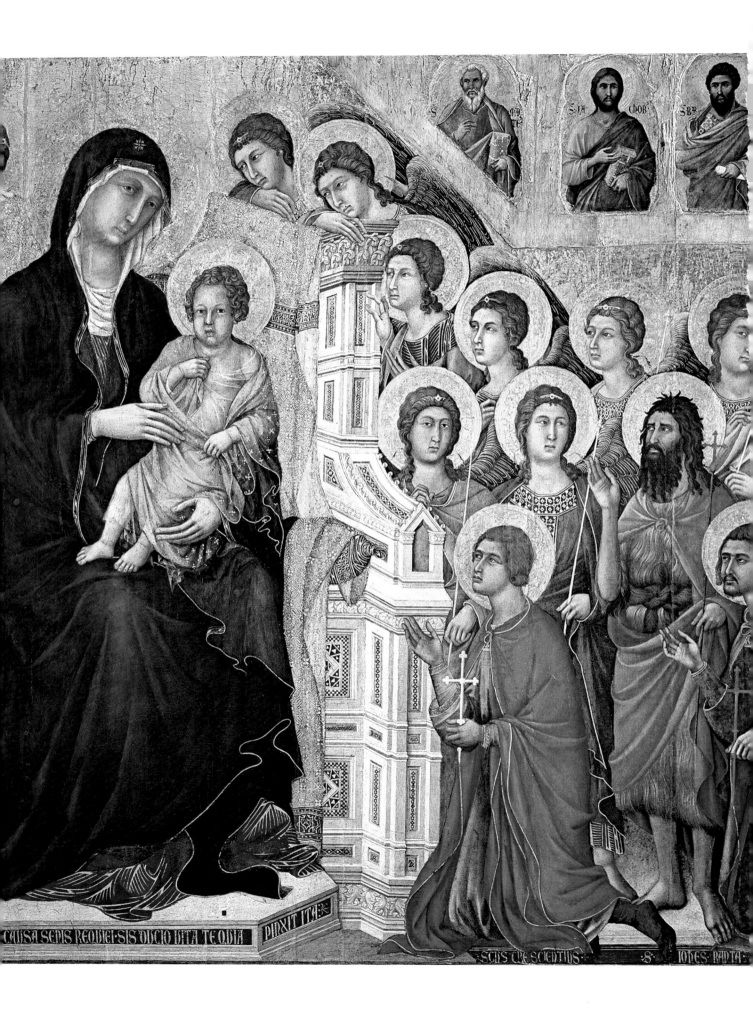

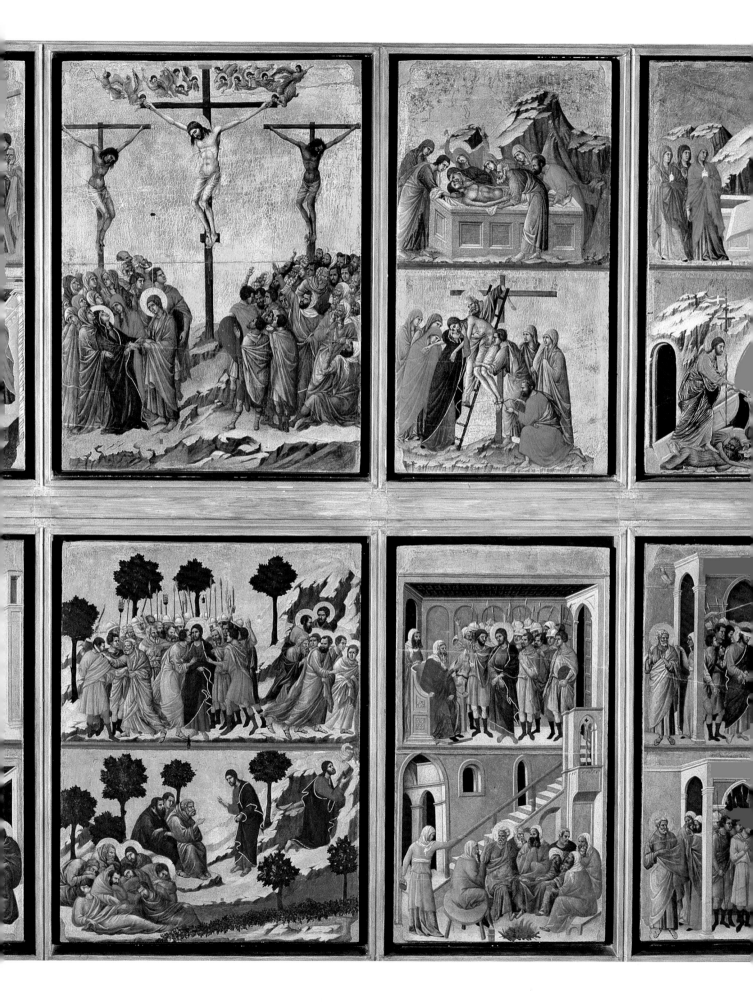

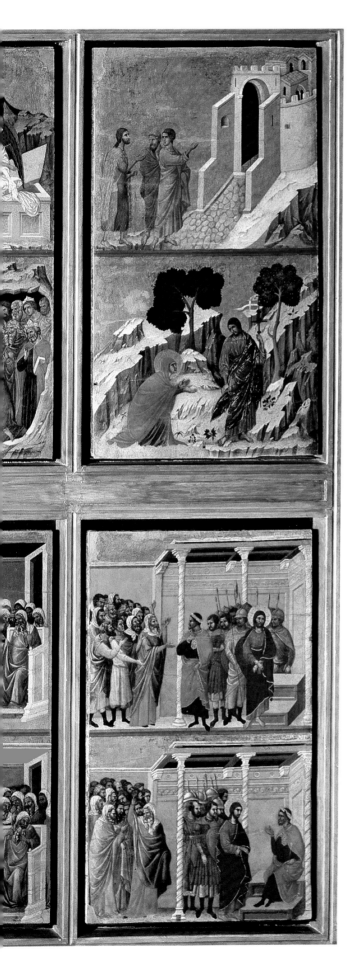

3. Duccio di Buoninsegna. *Maestà* (back), 1308–11. Gold and tempera on wood. Museo dell'Opera del Duomo, Siena

4. Photomontage of the back of Duccio's *Maestà* (fig. 3)

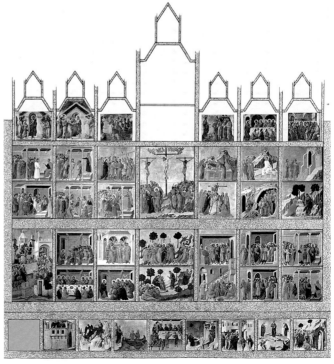

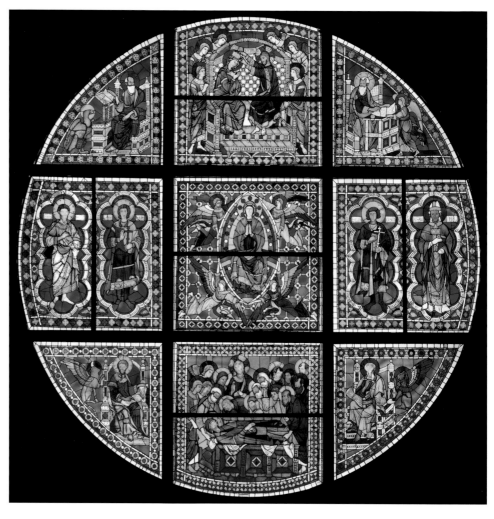

5. Duccio di Buoninsegna. *The Coronation of the Virgin, The Assumption of the Virgin, and The Burial of the Virgin, with Saints John the Evangelist, Matthew, Bartholomew, Crescentius, Savinus, Luke, and Mark*, 1287–88. Rose window of stained and painted glass, diam. 18 ft. 4 in. (5.6 m). Duomo, Siena

6. Interior of Siena Cathedral, looking down the nave toward the altar and the rose window. Duomo, Siena

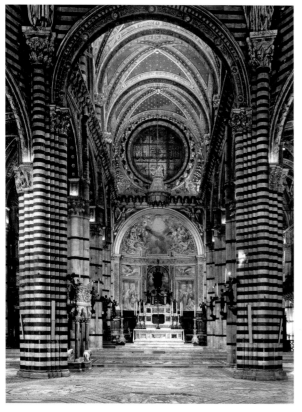

high altar of the cathedral, below the great rose window in the apse that Duccio had designed more than two decades earlier (figs. 5 and 6). In that dimly lit interior dominated by the black and white stripes of the marble revetment, the gold background would have come alive in the flickering candle-light. As the local historian Sigismondo Tizio observed two centuries after the altarpiece was made, the Virgin "seemed to gaze [at the people] in whatever place they were standing." Worshipers and art lovers alike were mesmerized.

Great attention was lavished on the altarpiece, the key ornament of the cathedral, which itself was greatly enlarged in an ambitious building campaign that began in 1317. Inventories drawn up in 1420 and 1423 relate that a baldachin supported on wrought iron poles was built over the painting. From three little tabernacles carved and gilded angels could be made to descend with the utensils for Mass. Four flying angels, each with a single candle kept burning day and night, were hung two in front and two behind, together with three lamps, two in front and one behind, and two ostrich eggs (a symbol of the Virgin Birth). Four further candle-bearing angels stood on the altar, at the sides of which were wrought

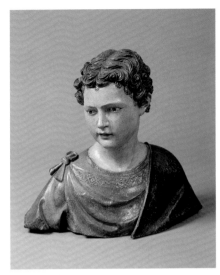

7–9. Francesco di Valdambrino (active by 1401, died 1435). *Saint Victor, Saint Savinus,* and *Saint Crescentius* (fragments from three full-length statues), 1408–9. Polychromed wood; h. 14¾ in. (37.5 cm), 16½ in. (42 cm), and 13¾ in. (35 cm). Museo dell'Opera del Duomo, Siena

iron grills with prongs for candles. An iron rod held a red curtain that could be drawn closed (it was painted with two angels holding a tabernacle); another curtain, fringed with multicolored silk threads, seems to have protected the predella of the altarpiece. Worshipers could attach wax votives in thanksgiving for favors received from the Virgin to a much larger iron grill that extended from the nearby columns of the church. In 1423 the marble pavement in front of the altar was decorated with a scene of David playing his harp accompanied by four musicians and a frieze of putti. Within a marble enclosure were eighty-eight magnificent inlaid wood choir stalls (begun in 1362 and later enlarged and reassembled in the choir) that established a sacred space for the use of canons and priests during Mass. A giant lectern stood at the center of the enclosure, which was entered through a wrought iron gate. The enclosure was ornamented with carved and painted statues of Siena's four patron saints and of Saints Peter and Paul. Two carved benches were provided, one to either side of the altar, for city officials attending Mass. Framing the rich ensemble and accessible

10. Pietro Orioli. *Cardinal Francesco Piccolomini and Members of the Various Political Divisions Offer the Keys of the City to the Madonna delle Grazie at Her Altar in the Cathedral* (detail from a book cover), 1483. Museo delle Biccherne, Archivio di Stato, Siena. The *Maestà* and its baldachin are visible at the far left, beyond the nave.

to the worshipers were large carved statues of the angel Gabriel and the Virgin of the Annunciation placed on columns beneath curtained marble tabernacles, with a receptacle for candles in front of the Virgin. On certain feast days this already dense assemblage was further enriched with polychromed seated figures of Siena's four patron saints, each holding a small casket with relics, that were commissioned in 1409 from one of the leading Sienese sculptors, Francesco di Valdambrino, "to put on the high altar of the cathedral on the high feast day." Bust-length fragments of three of these figures survive (figs. 7–9). A small painted book cover dating from 1483 that shows the interior of the cathedral (fig. 10) offers a glimpse of the whole extraordinary accumulation.

Once a year, on August 15, the *Maestà* provided an effulgent backdrop for the celebrations attending the feast day of the Assumption of the Virgin.

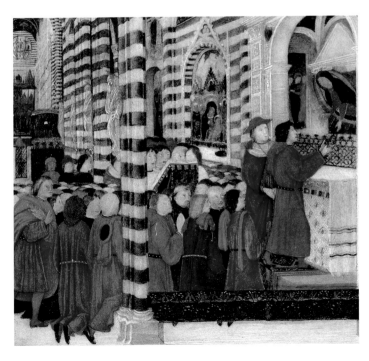

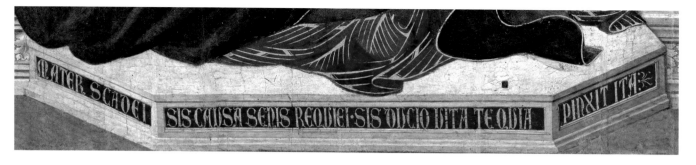

11. Detail of the inscription on the dais of the Virgin's throne in the *Maestà* (see fig. 1): "MATER S(AN)C(T)A DEI SIS CAUSA SENIS REQUIEI SIS DUCIO VITA TE QUIA PINXIT ITA" (O Holy Mother of God, may you grant peace to Siena and [grant] long life to Duccio, because he painted you thus)

On that day the city fathers and appointed representatives of its subject cities paid homage to the Virgin—the city's patroness—by processing to the cathedral and offering candles and tribute money before a particularly venerated image of the Virgin painted in commemoration of the Sienese military victory over the Florentines at the Battle of Montaperti in 1260 and installed on an altar in the right aisle. It is difficult, today, to re-create the fervor of this devotion to the Virgin, but so deeply was it engrained that as recently as the summer of 1944, when Siena was threatened with bombing as the Allied forces marched northward, citizens followed the timeworn tradition of processing from the *campo* to the cathedral to rededicate their city to her by offering up its keys. The *Maestà*'s importance as a civic as well as a purely religious work of art explains the first part of the prayer-like inscription Duccio painted in gold letters on the marble dais of the Virgin's throne (fig. 11): "MATER S(AN)C(T)A DEI SIS CAUSA SENIS REQUIEI SIS DUCIO VITA TE QUIA PINXIT ITA." "O Holy Mother of God, may you grant peace to Siena," it begins—an understandable sentiment in a city often torn by political strife. But only Duccio's unique stature as an artist could have allowed the truly astonishing second half of that inscription: "and [grant] long life to Duccio, because he painted you thus." The Latin words of this supplication are so arranged that the words "SIS CAUSA SENIS REQUIEI SIS DUCIO VITA TE QUIA" (grant peace to Siena / grant long life to Duccio) are on the front face of the dais, thus according Duccio the same status as Siena. The inscription seems all the more audacious in light of the fact that in the fourteenth century works of art were rarely signed, in any form. When signatures do appear they are invariably on the frame, not in the primary picture field, and they are mundanely worded: "hoc opus fecit . . ." (this work was done by . . .). The extraordinary concession—and there can be no question but that it was a concession that was much debated by the city fathers as well as the cathedral authorities—to allow Duccio's name and personal prayer such prominence is eloquent testimony to the esteem in which he was held.

The installation of the *Maestà* in the cathedral quickly embedded itself in the collective memory of the city, and the story of the procession is recorded by virtually every Sienese chronicler from the mid-fourteenth century on, alongside other events that shaped the city's history. Perhaps the most suggestive of these accounts was written by Agnolo di Tura del Grasso, who was attached to the financial branch of the city's government (the *biccherna*) and thus had direct access to primary documents now lost to us:

> The Sienese had a beautiful and rich painting done for the high altar of the cathedral. This altarpiece was completed at this time [i.e., 1311]. It was painted by the painter Duccio of Siena, who was among the most valiant painters of the day to be found in this land. He painted the altarpiece outside the Stalloreggi gate in the Laterino quarter in a house belonging to the Muciatti. And the Sienese people accompanied this altarpiece to the cathedral on the ninth of June at midday with great devotion and processions with the bishop of Siena, Ruggeri da Casole, and all the clergy of the cathedral and all the religious orders of the city and the lords and officials of the city and the *podestà* and

Captain of the People and all the most worthy citizens, hand in hand with lit lamps. And after them went the women and children, with all the bells ringing in glory. All day, out of devotion, shops were closed and many alms were given for the poor with many prayers and orations to God and his Mother, the Madonna and ever Virgin Mary, that as the advocate and protectress of the city she might preserve and increase the peace and well-being of Siena and its government and save it from all dangers and wickedness that might threaten it. And thus the altarpiece was put in the cathedral on the high altar, which altarpiece is painted on the reverse with episodes of the Old [sic] Testament and the Passion of Jesus Christ and on the front with the Virgin Mary and her son surrounded by many saints, ornamented with fine gold. And the work cost three thousand gold florins.

So compelling is Agnolo di Tura's account that it takes a practical mind indeed to ask the mundane question of just how this enormous and extremely heavy altarpiece, the frame of which was covered with gold leaf vulnerable even to rubbing by sweaty hands, could have been hoisted onto a cart and somehow propped upright to be wheeled around the uneven and steep streets of the city. Anyone who has seen large works of art moved by porters using only leather straps slipped beneath the object will quickly realize how much expertise as well as brute strength was involved. Even if we allow that parts of the *Maestà*, such as the predella with scenes from the life of Christ and possibly also the pinnacles, were constructed separately and could be left in the cathedral to be slotted into place on site, it was no small feat to stabilize the huge main panel on a cart.

What is reasonably clear is the route taken (fig. 12). Duccio's workshop was near the city gate known alternately as the Porta di Stalloreggi or the Due Porte, part of the eleventh-century walls surrounding the oldest part of the city. (The gate is still intact.) So the procession would have made its way from Duccio's workshop down the present-day Via di Stalloreggi (Duccio's workshop is sometimes identified with numbers 91–93 on this street) and its broader extension, the Via di Città, lined with patrician dwellings, toward the fan-shaped Piazza del Campo that every visitor to Siena remembers (fig. 13). What was to become one of the most beautiful squares in Italy had not yet assumed its definitive form,

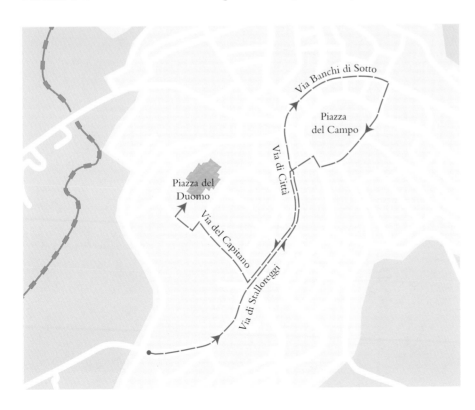

12. Map of Siena showing the probable route taken in 1311 when the *Maestà* was transported from Duccio's workshop in the Via di Stalloreggi to the cathedral in the Via del Capitano

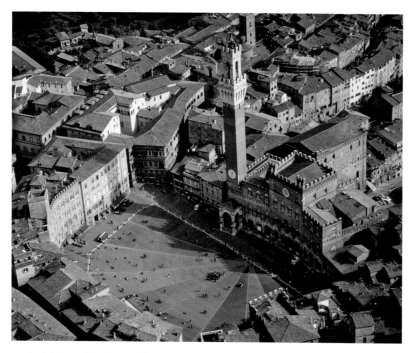

13. Aerial view of the Piazza del Campo, Siena

14. Facade and right side of the Siena Cathedral

but it already made an impressive backdrop. In 1311, though it still lacked the distinctive campanile, the Torre della Mangia (begun in 1325), the main core of the Palazzo Pubblico, the secular seat of government, was newly finished. The procession must have skirted the piazza on the present-day Banchi di Sotto and entered at the east end, where the incline is least extreme. From there it would have passed before the palazzo, possibly with the governors waiting outside, before returning up the Via di Città and down the Via del Capitano to the cathedral (fig. 14), where the altarpiece would have been lifted off the cart and carried into the church for placement on the high altar (see fig. 6). The same route was followed for the celebrations of the Feast of the Assumption of the Virgin on August 15, and it is still taken, in reverse sequence, during the famous horse race, the Palio, that has been held, with some

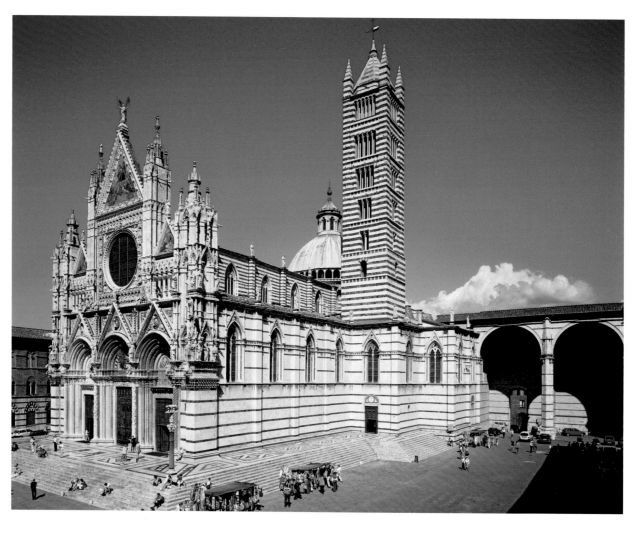

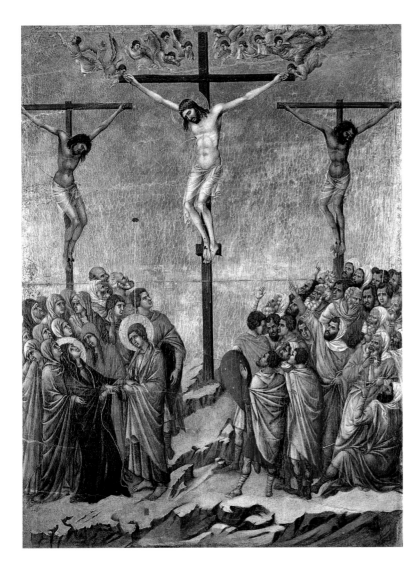

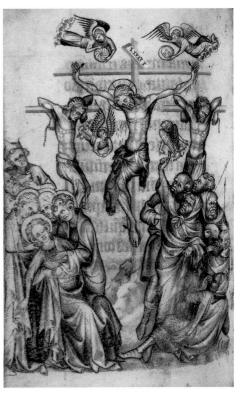

15. Duccio di Buoninsegna. *The Crucifixion* (panel from the reverse of the *Maestà*; see fig. 3)

16. Jean Pucelle (French, active ca. 1320–34). *The Crucifixion*, ca. 1324–28. *The Hours of Jeanne d'Evreux*, fol. 68v. Grisaille and tempera on vellum, 3½ x 2⅝ in. (8.9 x 6.7 cm). The Metropolitan Museum of Art, The Cloisters Collection, 1954 (54.1.2)

interruptions, each summer since at least the twelfth century. On July 2 and August 15, members of each Sienese neighborhood, or *contrada*, dressed in Renaissance costumes and twirling flags, pass beneath the archbishop's window, adjacent to the cathedral, for a blessing before proceeding to the *campo*, where the climactic moment before the start of the race is provided by the entrance of an ox-drawn cart bearing a large painted banner (the *palio*) and accompanied by trumpeters. Clearly, the procession for the *Maestà* was patterned on the festivities of the August feast day.

As Agnolo di Tura's chronicle implies, Duccio's name stood very high—and not only in Siena but throughout central Italy. In 1285 he had been commissioned to paint an enormous panel of the Madonna and Child enthroned for the Dominican Church of Santa Maria Novella in Florence (fig. 26). The success of that work seems to have led to further commissions from Dominican convents in Perugia (see fig. 34) and Siena as well as, presumably, from the Dominican cardinal Niccolò da Prato. Although Duccio never acquired the quasi-universal fame of Giotto, who was in demand throughout the Italian peninsula, from Milan to Naples, his influence extended north of the Alps, to Paris, thanks to the constant flow of foreigners passing through Siena en route to Rome. The French miniaturist Jean Pucelle, for one, studied the narrative scenes of the *Maestà* carefully (figs. 15, 16). By 1302 Duccio was the preferred painter of the Sienese government, for whose chapel in the Palazzo Pubblico he furnished a large panel of the Madonna and Child (destroyed).

He attained this position of favor despite frequent brushes with the law: in 1285 he was fined by the city for breaking a curfew; four years later he was penalized for not swearing allegiance to an ordinance promulgated by the captain of the people; and in 1302 he was fined again for obstructing a public street as well as for failing to appear for mandatory military duty. It would be dangerous to draw too delineated a portrait of Duccio from such meager documentation, which records only his infringements of the law. His motivations and personal character are perhaps better reflected in his tendency to indebtedness, despite a phenomenally successful career: the 1308 document relating to the *Maestà*, for instance, is not a contract but an arrangement for a loan. Duccio may well have been an early example of someone whose rebellious character was excused because of his exceptional artistic stature. How was it, then, that by the sixteenth century his position as one of the pioneers of European painting had become obscured and that even in Siena the only work by which he was remembered was the *Maestà*, which of course is signed?

Unlike Giotto, whose pupils were of distinctly smaller stature, Duccio fostered a new generation of painters every bit as talented and innovative as he was: a generation that included the brothers Pietro and Ambrogio Lorenzetti; Simone Martini, who replaced him as the government's favored artist and famously earned the literary praise of his friend the poet Petrarch; and Lippo Memmi, Simone's brother-in-law and sometime partner. Agnolo di Tura doubtless had these artists in mind when he declared that "the disciples of . . . Duccio were also great masters of painting." Sigismondo Tizio employed a more classically based if somewhat shopworn simile: "Out of his workshop, as though from the Trojan horse, came forth excellent painters." Each of these artists may have spent some time in

Duccio's shop and may even have been engaged to work on the *Maestà*. But regardless of whether they had anything to do with its production, they were deeply indebted to its example: the dazzling sense of pattern and color, the keen sense of narration, the manifest interest in the investigation of spatial problems, and the lyrical beauty of the figures. Paradoxically, their success in building on Duccio's legacy and expanding still further the expressive limits of painting meant that, inevitably, his pioneering work came to appear somewhat old-fashioned. When in the fifteenth century the sculptor Lorenzo Ghiberti, the author of the Gates of Paradise on the Florentine Baptistery, recorded his views on art in his *Commentarii*, he could scarcely contain his enthusiasm for the narrative brilliance and mastery of spatial illusionism of Ambrogio Lorenzetti's frescoes. He also gave nodding acknowledgment to the refined delicacy of the work of Simone Martini, whom, he informs us, the Sienese considered their greatest painter. But although he admired the *Maestà* and called Duccio a "most noble painter," he felt the artist's work was too

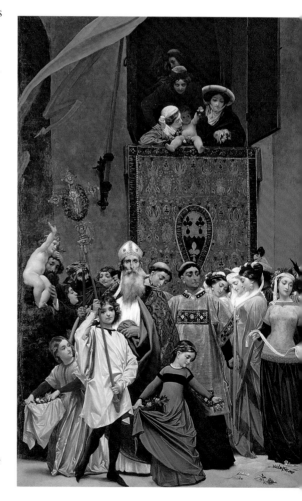

much attached to what he saw as the degenerate traditions of Byzantine art ("la maniera Greca")—the style that Giotto had made obsolete. Ghiberti seems to have been unaware that a generation separated Duccio's work from that of Ambrogio Lorenzetti and Simone Martini. Nor did he fully appreciate the way Duccio managed to invest his art with a recognizably human dimension without sacrificing its potential to suggest the numinous—the way he intentionally employed conventions deriving from medieval and Byzantine practice to add a spiritual dimension to his work.

From Ghiberti's verdict it was only a small, but crucial, step to Giorgio Vasari's perfunctory treatment of Duccio in his *Lives of the Most Eminent Painters, Sculptors and Architects* (1567). Vasari managed to further confuse matters by making Duccio a younger contemporary of Simone Martini and Ambrogio and Pietro Lorenzetti, thereby transforming the teacher into the pupil and the father of Sienese painting into a name without an anchor, for the normally assiduous biographer was unable to locate the *Maestà* in the cathedral, though it was perfectly visible in the transept of the church, to which it had been moved in 1506. (The problem resided in the fact that Ghiberti, by a mental lapse, had described it as showing the Coronation of the Virgin, and Vasari was unable to locate an altarpiece with this subject!) Given the impact of Vasari's work on later critics, it is no wonder that Duccio's rightful place as one of the pioneers of European painting was lost.

Ironically, though, the fame of the *Maestà* did not entirely escape Vasari's notice, for he must have known the chronicled accounts of its triumphant installation. Always keen for a story that testified to the high esteem artists could achieve by their genius, and an unapologetic protagonist of Florence as the fountainhead of Italian painting, he adapted the story

17. Frederic Leighton (English, 1830–1896). *Cimabue's Celebrated Madonna Is Carried in Procession through the Streets of Florence*, 1854–55. Oil on canvas, 7 ft. 2⅝ in. x 17 ft. ¾ in. (2.2 x 5.2 m). Royal Collection (RCIN 401478), on loan to the National Gallery, London

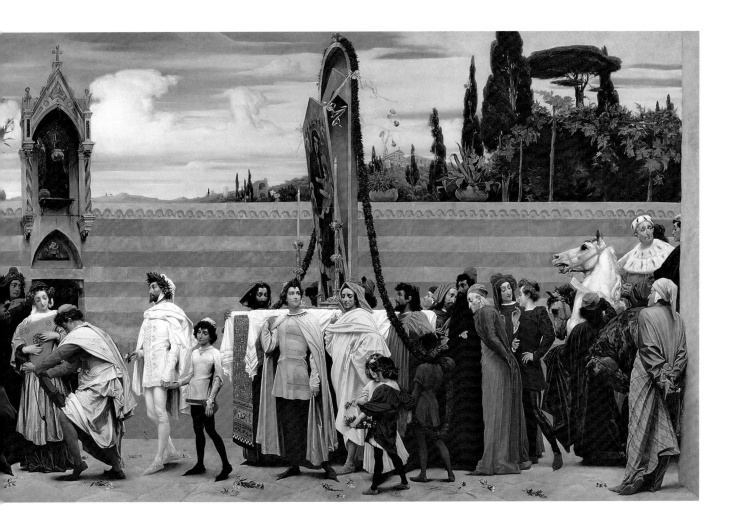

to suit one of his heroes, Cimabue (ca. 1240–after 1302), the teacher of Giotto, and a painting he identified as marking the turning point from the Byzantine to a more modern, naturalistic style. The picture in question is the celebrated *Ruccellai Madonna* (fig. 26), which confronts visitors to the first gallery of the Uffizi in Florence. Vasari thought it was painted about 1294 by his protagonist, but we know it was actually painted by Duccio between 1285 and about 1287 for a chapel in Santa Maria Novella. Here is Vasari's account:

> This work was larger than any . . . that had been painted up to that time, and some of the accompanying angels show that although Cimabue still retained elements of the Greek [or Byzantine] manner of painting, he was gradually approaching . . . the lines and style of modern times. As a result, this work so astonished the people of the day . . . that they carried it with great rejoicing and with the sounding of trumpets from Cimabue's home to the church with solemn procession, and Cimabue himself was greatly rewarded and honored.

Whereas we must imagine for ourselves the procession that attended the completion of the *Maestà*, for the one Vasari described we can turn to the imaginative re-creations of several nineteenth-century paintings, among which the most evocative is by the fashionable Victorian painter Sir Frederic Leighton (fig. 17). Like a savvy set designer, Leighton took enormous care with certain details of the picture, which he painted in Rome in 1854 and 1855. During a two-month sojourn in Florence he did drawings from models to lend the figures greater authenticity, and he carried out topographical views of the Porta di San Niccolò and the Church of San Miniato al Monte, situated in the hills above the city. But he did not trouble himself much with the actual mechanics of the event any more than he worried about situating the procession topographically—though the striped wall against which the procession takes place recalls the wall surrounding the cemetery of Santa Maria Novella. He showed the enormous and heavy panel, which required nine massive iron rings to hold it in place in the church, on a draped cart, held implausibly angled forward by fluttering ribbons attached to a flimsy wood framework. Enormous candlesticks stand in front of it, and young pages walk alongside holding a lush garland that extends from the arched wood support. The carpet-draped float is carried—apparently effortlessly—by six well-dressed porters whom Leighton ingeniously identified with painters and sculptors active at the time of Cimabue. They are preceded by a splendid but stern-looking bishop followed by tonsured priests and an amiable group of young women and men singing and playing instruments. Behind the float is Charles of Anjou, mounted on horseback, amid a group of patrician men. At the extreme right Dante pensively takes in the festivities, directing his gaze toward a laurel-crowned figure dazzlingly dressed in white and a sweet-faced youth in a white tunic and black leggings. These figures are Cimabue and his young pupil Giotto, who Vasari tells us was discovered in the countryside amusing himself by sketching sheep onto a stone tablet while he performed his tasks as a shepherd. Cimabue got permission to train the boy, only to see himself outstripped by his gifted pupil. Dante immortalized their relationship with these lines from *The Divine Comedy* (*Purgatorio* 11.94–96): "Once Cimabue thought to hold the field as painter, but Giotto is now all the rage, dimming the luster of the other's fame." It is an epithet that might well have been adapted to Duccio and his pupils, had Siena produced a poet of Dante's stature. One of the reasons this event captured the imagination of so many nineteenth-century painters and writers was the way it brought together three of the great figures of Florentine culture in celebration of a work of art. Leighton has cleverly interwoven these references while fully indulging in the prevailing taste of the mid-nineteenth century for all things medieval.

Like Leighton's painting, Vasari's story is a brilliant piece of imaginative historical fiction. However, not only did he get wrong the name of the artist responsible for the *Ruccellai Madonna* as well as its date, but the event he describes almost certainly never happened: not a single document or other archival notice attests to it. Yet he was right to place as one of the pivotal paintings of his narrative Duccio's altarpiece—the artist's first documented work—for the picture was every bit as revolutionary in its time as the *Maestà*, painted more than two decades later.

This anecdotal digression not only elucidates the problems of mentally reconstructing historical events surrounding the creation of great works of art in the distant past, but it serves to situate Duccio at the very center of creativity in those momentous decades when the foundations for European painting were laid, a period that had as its central event the decoration between 1288 and 1292 of the upper church of San Francesco at Assisi by a team of artists that included both Cimabue and Giotto. As we shall see, Duccio closely studied this cycle of frescoes not long after its completion.

What made the *Maestà* so special? First, Duccio's representation of space. Not the compact, tightly structured, cubic space we have come to associate with the work of Giotto, in which the architectural setting is invariably conceived to enhance the figural content, but a more pictorial, panoramic spatial setting incorporating a plethora of details culled from the world of everyday life, so that the event relates to the contemporary world of his viewers. Take, for example, the scene from the reverse

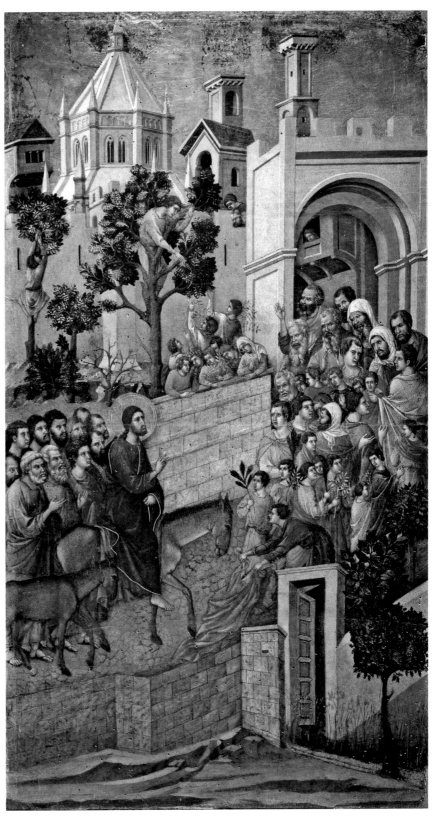

18. Duccio di Buoninsegna. *The Entry into Jerusalem* (panel from reverse of the *Maestà*; see fig. 3)

side of the *Maestà* showing Christ's triumphant entry into Jerusalem (fig. 18), perhaps the most complex and suggestive urban view of its time. The event is staged on an incline, viewed from the far side of a city wall intended to evoke those surrounding Siena (the commune's black and white insignia, the *balzana*, is painted on the wall next to an open door that leads into a garden or passageway). Figures are arbitrarily cropped along the

19. Duccio di Buoninsegna. *The Temptation on the Temple* (panel from the back of the predella of the *Maestà*; see fig. 4). Museo dell'Opera del Duomo, Siena

vertical margins so as to suggest a moment in time—a fleeting action miraculously captured in paint. How marvelously Duccio has choreographed the scene to bring out the salient players and their contrasting emotions as well as to introduce touches that relate the sacred event to everyday life! An excited crowd welcomes Christ, garbed in a gold-trimmed lapis lazuli–colored cloak, his right hand extended in a gesture of blessing, his concerned apostles following in serried rows. One youth spreads a costly red cloth beneath the hooves of the donkey, while priests and rabbis wearing worried or disapproving expressions spill out of the arched gateway, through which we see a child peering curiously out of an upper story window. Beyond the wall bordering the other side of the paved road two youths climb trees to gather branches to lay before Christ; one has just thrown some to three waiting companions. They are observed by two figures positioned behind the coral-colored crenellated city wall, above which towers the massive octagonal dome of the temple, the banners on its lantern fluttering in the breeze. It is a scene blending ceremony with topicality.

In another, alas damaged, scene showing Satan urging Christ to throw himself down from the temple (fig. 19), Duccio inverted the conventional figure-to-architecture

relationship: the figures, although outsize, seem almost secondary to the architecture. Satan and Christ are shown standing on the balcony of an elaborately described octagonal building, a lateral side of which is aligned with the picture plane while two other facades are shown foreshortened, establishing an insistently three-dimensional effect. Although the rules of single-point perspective were not to be invented for another century, Duccio attempted to depict the various architectural features as though they were viewed from a position more or less along the juncture between the front and right-hand facades. It was not an easy feat, and he ran into some difficulties with the dentils around the piers of the building and where the tracery of the Gothic windows proved too intricate to bring into complete conformity without a guiding mathematical perspective system. But the effort and the achievement are notable. Still, they are no preparation for the view through the open door into the dimly lit interior of the building, with its multicolored marble pavement and columns supporting a vaulted aisle. Through the upper story windows still more of the interior structure is visible. Were it not for the figures of Christ and Satan, the picture could lay claim to being the first compelling piece of pure architectural painting in European art. It sets the stage, so to speak, for Jan van Eyck's extraordinary *Madonna in the Church* (fig. 20) of more than a century later. The object of Duccio's tour de force of the imagination was to assert the scene as the re-creation of a real event and to compel the viewer to apply to the picture his or her own experience of the world—to envisage the biblical scene as though it were a contemporary event. In effect Duccio applied to his scenes a form of devotional practice— of self-identification with the events in the Bible—that was actively promoted by the great preaching orders founded in the thirteenth century, the Franciscans and Dominicans. At the same time, the enlarged scale of the figures is a reminder that this is no everyday drama.

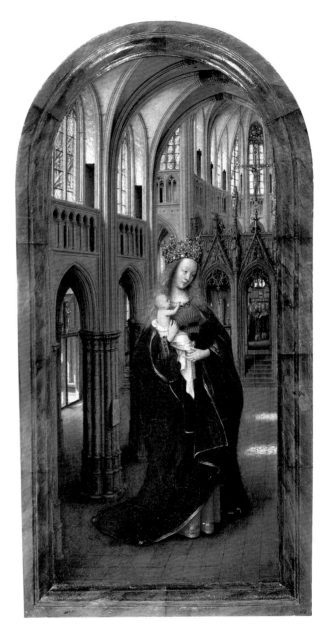

20. Jan van Eyck (Netherlandish, active by 1422, died 1441). *The Madonna in the Church*, ca. 1425. Oil on oak panel, 12¼ x 5½ in. (31 x 14 cm). Gemäldegalerie, Staatliche Museen zu Berlin (525C)

The companion scene, in which Satan takes Christ to a mountaintop and tempts him with worldly dominion (fig. 21), contains one of the earliest and most evocative panoramic landscapes in early Italian painting. The barren hills (Christ's temptation took place in the desert) are arranged and colored so as to suggest a deep space, and the walled towns and castles have been imagined not as an accumulation of flat, arbitrarily juxtaposed buildings but as carefully constructed places that the viewer can enter and walk about in in his or her imagination. All we have to do to realize the potential of this scene as pure genre is to eliminate in our mind's eye the outsize figures of Satan, Christ, and two angels, whose very incongruous scale once again establishes a different kind of reality. As initially conceived by Duccio, the scene was even more extraordinary, for a technical examination undertaken at the Metropolitan in 2007 revealed that the two angels, whose oversize presence behind the hills tends to collapse the space, were added in a second stage: Duccio had shown only Satan and Christ against the landscape and gold background (fig. 22). Evidently a cleric

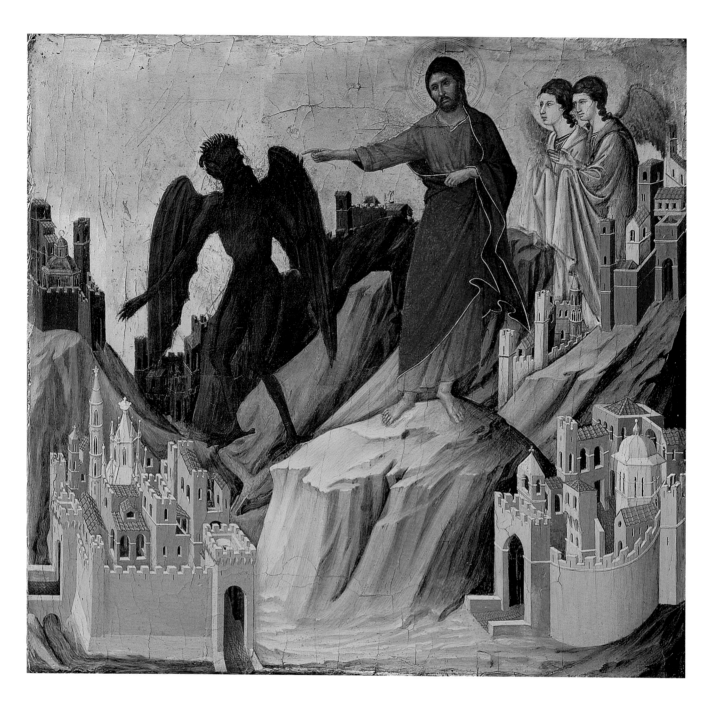

21. Duccio di Buoninsegna. *The Temptation on the Mountain* (panel from the back of the predella of the *Maestà*; see fig. 4). Frick Collection, New York

objected to the absence of the angels the Bible says ministered to Christ following his temptation. So the gold in the area the two angels now occupy was scraped off and the figures hastily inserted by an assistant who did not even bother to underpaint their faces with the traditional greenish preparation (terra verde).

If we mentally (or, with the help of a computer, virtually) eliminate the two offending angels, we can see that the space is masterfully handled and the hills darken progressively in the distance—perhaps the first instance of an attempt to replicate the effects of atmospheric perspective in terms of Aristotelian and medieval writings on optics. Of course, in actuality distant objects become hazier and bluer as they recede in the distance, but only in the fifteenth century do we find observation replacing what theorists continued to describe as a progressive darkening of color. (In his 1435 treatise on painting Leon Battista Alberti still advised painters that "the greater the distance, the more surfaces will appear dark.")

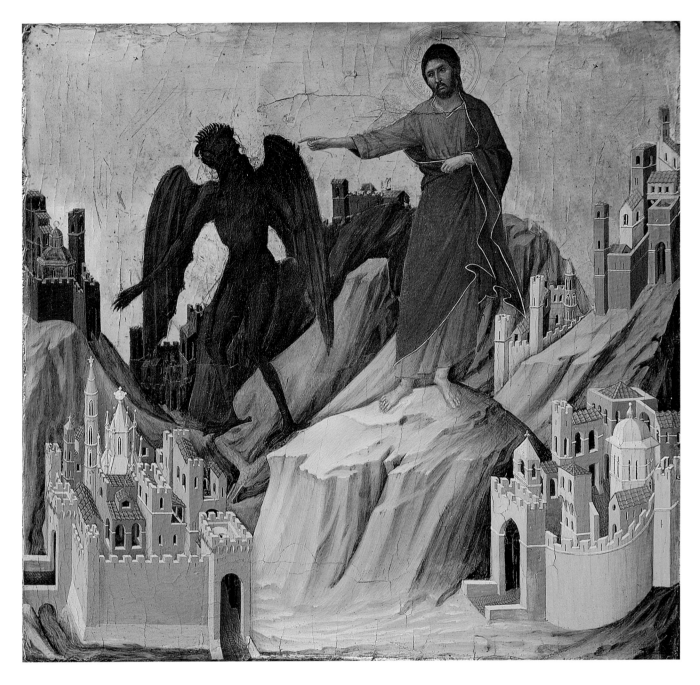

22. Duccio's *Temptation on the Mountain* (fig. 21) with angels eliminated from upper right by digital manipulation (courtesy of Charlotte Hale)

So remarkable is the spatial complexity of these scenes that one recent critic has argued—perversely—that they were painted by Pietro and Ambrogio Lorenzetti working under Duccio's direction. Both artists certainly studied the *Maestà* with a keen, analytic eye, and Ambrogio went on to paint the grandest of all fourteenth-century landscapes on a wall of the Palazzo Pubblico. However, that either of them would have been allowed a free hand in such conspicuous scenes is in the highest degree unlikely. Duccio certainly employed assistants, but like every other great artist he used them in those parts of the altarpiece that were the hardest to see: it is in the pinnacles of the altarpiece that his innovative designs were ineptly translated by pupils, so that the settings are sometimes flat and unconvincing. In those cases, Duccio must have provided his assistants with drawings or patterns for the settings and others for the figural components: the integration of the two usually outstripped their abilities.

Duccio was certainly aware of the work of Giotto—the *Madonna and Child* recently acquired by the Metropolitan Museum (fig. 36) is one of the clearest demonstrations of

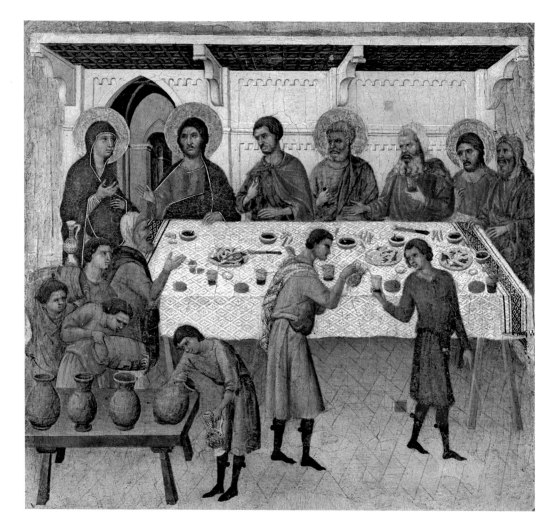

this. But when his rendition of the Wedding at Cana (fig. 23), yet another scene from the predella of the *Maestà*, is compared with the scene of the same subject that Giotto frescoed in the Arena Chapel in Padua just a few years earlier (fig. 24), the differences in their approach to space and narration come into sharp focus. Whereas Giotto thought out his composition with an unerring sense of compositional structure, interval, and emphasis, with the bride isolated along the vertical axis of the painting and the jugs of water and a back-viewed servant used to define the picture plane, in Duccio's version of the scene—which is less than one-hundredth the size of Giotto's and necessarily employs a gold leaf background—the figural and architectural components are far more loosely coordinated. It was Duccio who took fullest advantage of the open door to suggest further rooms extending beyond the one we see. He also employed a higher viewing point, to emphasize the depth of the scene. Both artists included two different moments in the narrative. In Giotto's fresco Christ gives the command to serve the water that has been miraculously transformed into wine, while the Virgin, on the right, seated next to the bride, instructs the appropriately potbellied steward to taste a glass. (How many smiles his wonderful characterization must have provoked!) In Duccio's rendition, Christ, seated next to the groom, is shown initially protesting the Virgin's supplication to perform a miracle—"Mine hour is not yet come," he says (note how the open door sets off his gesture)—while in the foreground servants follow his instructions to fill empty vessels with water; the water in one of the four jugs has already been transformed into wine

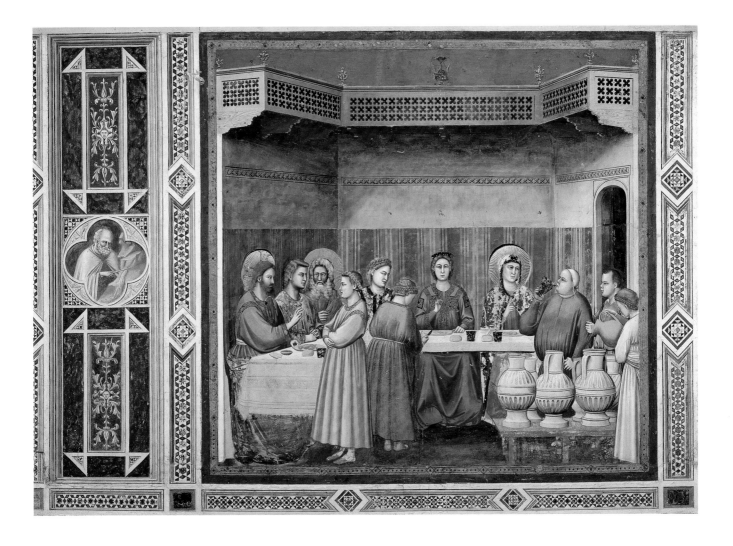

24. Giotto di Bondone. *The Wedding at Cana*, ca. 1305. Fresco. Cappella degli Scrovegni (Arena Chapel), Padua

and is being distributed. Both artists have enlivened the scene with details culled from contemporary life: the bride's dress, the banded tablecloth, the striped textile decorating the walls in Giotto's depiction; the herringbone brick pavement, the ceramic pitchers, the diamond-patterned tablecloth, and the cut-up meat on the dishes in Duccio's. But whereas the narrative tone in Giotto's scene is solemn and the action is stilled, in Duccio's the foreground is a hubbub of activity, and details such as the spindly legged servant with a towel slung over his shoulder who pours a glass of wine for his companion, shown turning backward as he walks away, create the impression of an action unfolding before our eyes. Duccio's digressive approach to narration defined the character of Sienese painting.

The *Maestà* was commissioned by the Opera del Duomo, the administrative board of the cathedral. This was no mere religious body. Its members were prominent citizens who answered to the civic government, with the ecclesiastical authorities playing an advisory role. The *operaio dell'opera del duomo* (master of the cathedral works) was appointed and salaried by the city: to a fourteenth-century Sienese, the distinction we draw between civic and religious life would have been incomprehensible. Indeed, the kinds of commissions found in civic and ecclesiastical buildings overlapped. In 1315 the *Nove* hired Simone Martini to fresco the end wall of their council chamber with an enormous *Maestà*, an updated version of Duccio's altarpiece. Other walls of the room were decorated with images celebrating the expansion of the territory under Sienese rule, and one of these, dramatically uncovered in a

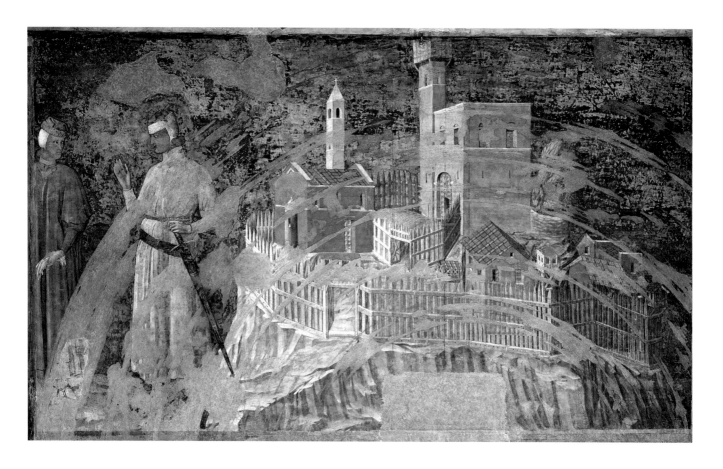

25. Probably Duccio di Buoninsegna. *Surrender of a Town, Possibly Giuncarico, to Siena*, 1314? Fresco, 7 ft. 2⅝ in. x 12 ft. 5 in. (2.2 x 3.8 m). Sala del Mappamondo, Palazzo Pubblico, Siena

restoration campaign in 1980–81, represents the transfer of authority of an embattled town to a Sienese official (fig. 25). In the fresco we find the same use of a double scale—one for the figures and another for the landscape—as in *The Temptation on the Mountain* (fig. 21), and the sharply chiseled edges of the plateau on which the town is sited and the marvelous structural clarity of the buildings are also characteristic of Duccio. The council chamber fresco makes a compelling claim to being his only surviving secular work, done, moreover, for the most important room of a major civic building.

Space and a digressive approach to narration are certainly two features that distinguish Duccio's legacy. But to better underscore another key aspect of his art—the refined lyricism of his Madonnas and their profoundly sacred quality—it is worth returning briefly to his earliest documented work: the *Ruccellai Madonna* (fig. 26), painted twenty some years before the *Maestà*. Many of the traits that come into full flower in Duccio's mature work make their first, budlike appearance in this majestic and beautiful altarpiece he painted for a confraternity chapel in Santa Maria Novella. In this case the most telling comparison is not with a work by Giotto, who in 1285 was not yet twenty, but with a painting by Giotto's teacher, Cimabue (the artist to whom Vasari mistakenly ascribed the *Ruccellai Madonna*), for there can be little doubt that Duccio's early work was deeply influenced by the painting of his Florentine elder, and vice versa. Cimabue's chronology is far from clear, but the picture that bears most directly on the character of the *Ruccellai Madonna* is a large altarpiece he painted, perhaps in the years around 1280, for the Church of San Francesco in Pisa (fig. 27). In this enormous panel of the Madonna and Child the Florentine painter made a number of advances over earlier treatments of the theme. The throne, imagined as a large wood chair with a footstool, is viewed obliquely so that its structure is clearly discernible. The Virgin's body fills the space of the throne, and her feet are arranged on the individual steps of the footstool. Not surprisingly, certain problems go unresolved: How, for example, can

the position of the legs of the throne and their placement on the zigzag molding supporting them be explained? And how is it possible for the bottommost left-hand angel to embrace the back of the throne while his companion holds the front, though their positions in space are aligned? Duccio's *Ruccellai Madonna* is very much a corrective of Cimabue's picture. The structure of his throne is both more complex—it employs Gothic arcades between the vertical members—and spatially more consistent. (The remarkably innovative Gothic arcades—something Duccio never repeated—may have been inspired by French ivories, which were much prized in Italy.) The pose of the Virgin is also far more convincingly articulated. There is still a contradiction between the position in space of the two bottommost angels and the parts of the throne they are imagined to be holding, but the stepped platform on which the throne is placed makes the spatial intentions of the artist clear. No less notable is the way the intricately patterned cloth of honor is shown falling in rich folds, as though suspended from the back of the throne, and the way both the cloth of honor and the vermilion pillow can be seen through the Gothic arcades, a prelude to the view through the temple door in the *Maestà*. The modeling of the Virgin's drapery into myriad cascading folds, emphasized by the undulating gilt hem, is nothing short of miraculous (the original azurite blue was only recovered when the picture was cleaned between 1988 and 1990). By comparison, Cimabue's image, with its cloisonné-like network of folds, still belongs to the realm of marvelous pictographs.

Aside from the issue of spatial logic and naturalism, the expressive quality of the two images could hardly be more different. There is about Cimabue's picture an abstract, hieratic formality that in Duccio's acquires a deeply human dimension. Quite apart from the rigid symmetry of Cimabue's composition, evident even in the distribution of the colors, the angels all turn toward us, as though posing for an official portrait. The rather formal and off-putting effect is not lessened by their stern expressions and the emphatic delineation of their schematized features. The Virgin, too, stares out at us, and her child is depicted as a miniature philosopher or teacher, dressed in a toga and holding a scroll. In Duccio's painting, by contrast, the angels—each rendered in different color combinations that keep the viewer's eye constantly moving—gaze raptly at the Virgin, establishing a private, sacred realm within the picture. The Christ Child, clothed in a transparent tunic that contrasts brilliantly with the gold-highlighted red cloth that signifies his divinity, no longer sits stiffly on his mother's knee, like a puppet. Rather, he pushes one foot against her thigh while he retracts the other, providing an early example of implied movement and an exercise in foreshortening aimed at mitigating an overly hieratic effect. As in Cimabue's picture, so in Duccio's the infant Christ extends one hand in a symbolic gesture of blessing, but here there is something almost spontaneous about it. Rather than staring directly out of the picture, the Child seems fascinated by the gesture he has newly discovered, as it were. It is the Virgin who looks out of the picture, and she does so with a sweet, sidelong glance, as though she has just taken note of our presence and is assuring us that we are welcome to her sacred precinct. Her stylized features are still marked by workshop formulas passed down over the centuries, but the delicacy of the modeling confers on her a warm humanity. She is the god-bearing mother, the person that Dante, in *The Divine Comedy*, has Saint Bernard address as "O Virgin Mother, Daughter of thy Son, lowliest and loftiest of any creature, fixed goal decreed from all eternity, you are the one who gave to human nature so much nobility that its Creator did not disdain His being made its creature" (*Paradiso* 33.1–5). Dante's series of paradoxes provide, I think, the key to the way Duccio's Madonnas and saints seem at once approachable and human and beyond common experience. To a greater degree than any other painter, Duccio explored a realm that is transcendent yet human, resplendent yet approachable.

(overleaf)
26. Duccio di Buoninsegna. *The Ruccellai Madonna*, 1285–ca. 1287. Gold and tempera on wood, 14 ft. x 9 ft. 6 in. (4.3 x 2.9 m). Galleria degli Uffizi, Florence

27. Cimabue (ca. 1240–1302). *Maestà*, possibly ca. 1280. Gold and tempera on wood, 14 ft. x 9 ft. 2 in. (4.3 x 2.8 m). Musée du Louvre, Paris (254)

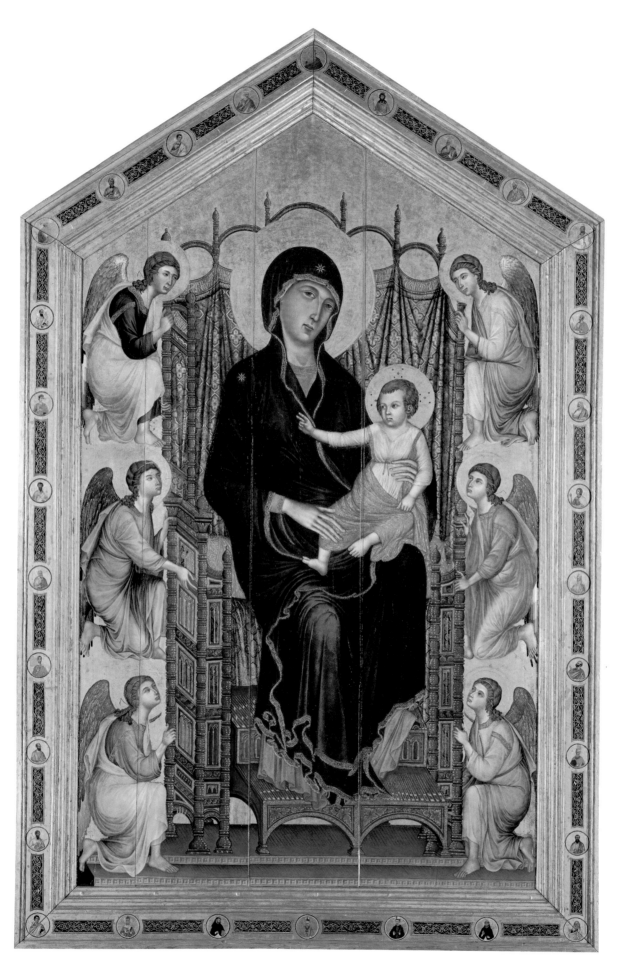

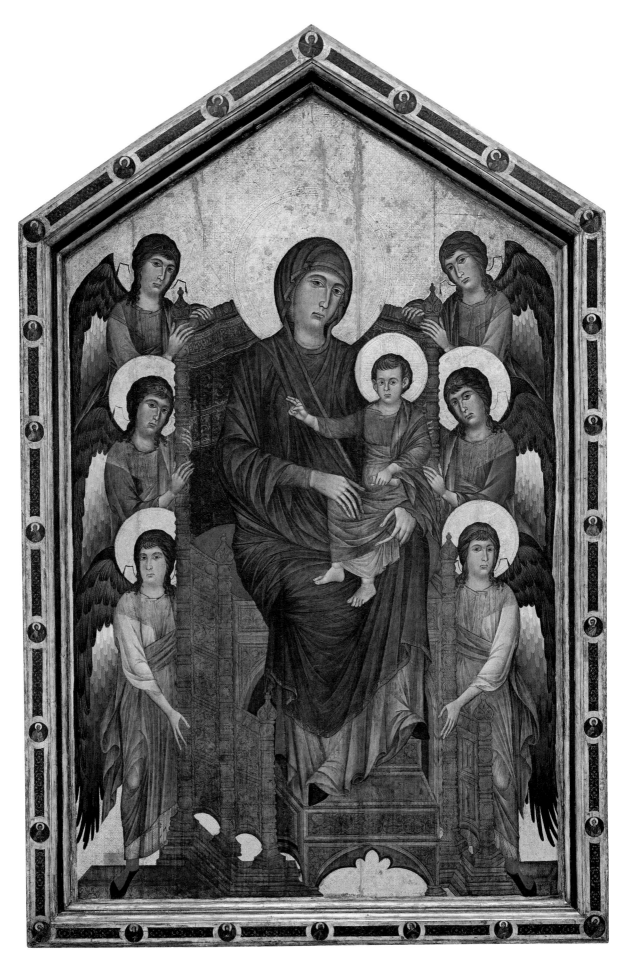

33

28. Duccio di Buoninsegna. *Madonna of the Franciscans*, probably ca. 1284–85. Gold and tempera on wood, 9½ x 6¾ in. (24 x 17 cm). Pinacoteca Nazionale, Siena (20)

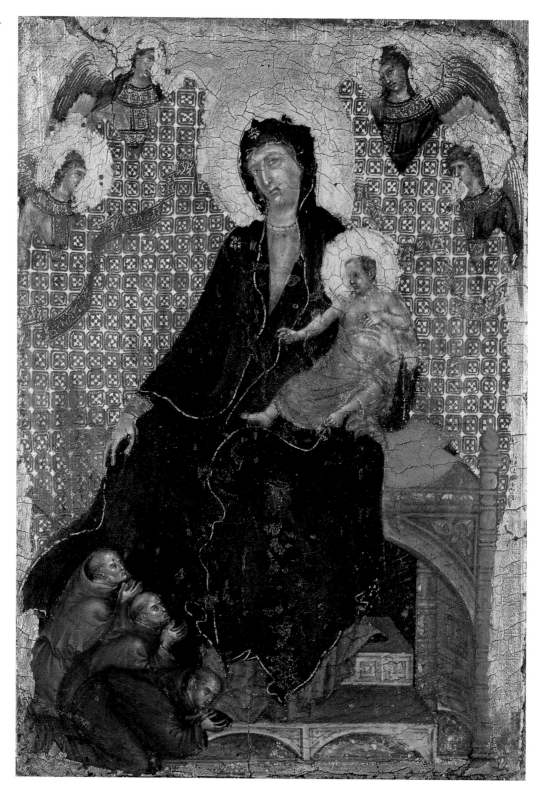

Probably a short time before he began work on the very large altarpiece for Santa Maria Novella, Duccio painted, on a miniature scale, a no less inventive panel for the devotion of a Franciscan friar (fig. 28). Once again, he showed the Madonna and Child on a throne, which is similar to the one in the *Ruccellai Madonna* in its orientation and components but does not yet employ Gothic decorative details. The Virgin's pose is a complex one: while her legs are angled to the right, her upper torso is turned to the left, as with one hand she protectively enfolds beneath the hem of her cloak the diminutive figures of three friars.

(This motif—the Madonna of Mercy—
is specifically Franciscan in origin and
is found as far afield as in contemporary
Armenian illuminations, though never
with the complexity with which Duccio
endowed it.) The friars are so placed that
their superimposed bodies suggest the
sequence of a single, continuous action of
genuflection—we might think of them as
a sort of thirteenth-century prologue to
Marcel Duchamp's 1912 *Nude Descending a
Staircase* (Philadelphia Museum of Art). The
friars are performing the Byzantine ritual
of self-abasement known as *proskynesis*
(one embraces the Virgin's foot to kiss it).
This extraordinarily original composition,
unfortunately marred by losses (the ab-
sence of modeling in the Virgin's drapery
that compromises a reading of her com-
plex posture; the flat pattern of the cloth of
honor, which originally would have been
modeled with glazes), is at the farthest
remove from the majestic, static Madonnas
painted later by Giotto.

Evidently the novelty of the *Ruccellai
Madonna* was not lost on either Cimabue
or his very young pupil Giotto. There is
in the Tuscan town of Castelfiorentino a
half-length image of the Madonna and
Child (fig. 29) that some scholars ascribe
to Cimabue assisted by Giotto. If this is
so—and an alternative suggestion is that it
is actually a collaboration between Duccio
and Cimabue—the painting would reveal

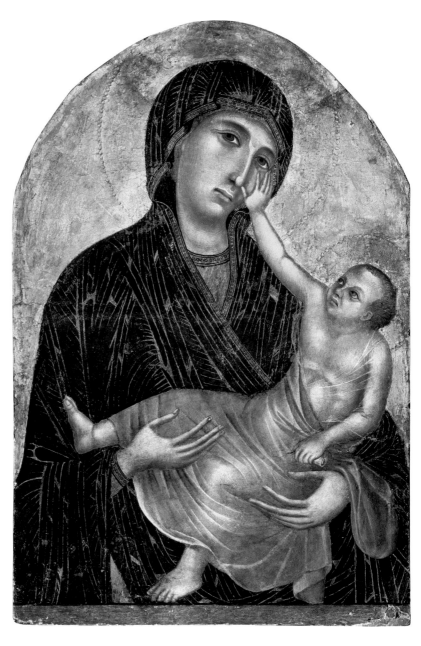

29. Attributed to Cimabue,
assisted by Giotto, or to
Duccio and Cimabue. *Madonna
and Child*, ca. 1285. Gold and
tempera on wood, 26¾ x
18½ in. (68 x 47 cm).
Museo di Santa Verdiana,
Castelfiorentino

the older Florentine artist's attempt to capture some of the refined humanity of Duccio's
masterpiece while Giotto, to whom the rambunctious Child has been ascribed, audaciously
takes the next step in this unfolding pictorial revolution.

The *Ruccellai Madonna* demonstrates that well before Duccio's encounter with the art of
Giotto at Assisi, he was a proponent of innovation and a key figure in the events that were to
redefine the art of painting. Although we are accustomed to interpreting fourteenth-century
art as though it were the single-handed creation of Giotto, this view has no more validity
than the idea that twentieth-century art is due exclusively to Picasso. As is so often the case,
there was an extraordinary exchange among artists, with a variety of positions taken. While
Giotto was unquestionably the towering genius and the most extreme in his insistence on
painting as a rational discipline—a means of objectifying experience—Duccio championed
a more subjective approach. We have already seen how different their sense of narrative
was. No less so was their conception of devotional imagery and its affective qualities. If
we compare the Madonna and Child in the *Maestà* (fig. 30) and Giotto's celebrated
painting for the Church of Ognissanti in Florence (fig. 31), which must date to within a

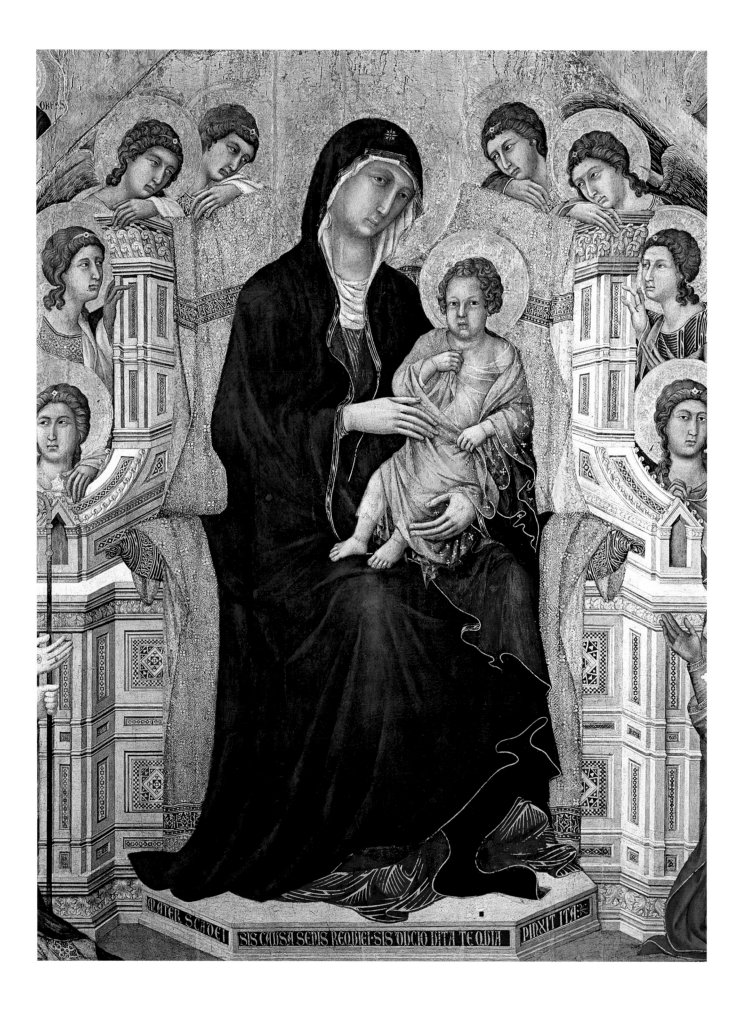

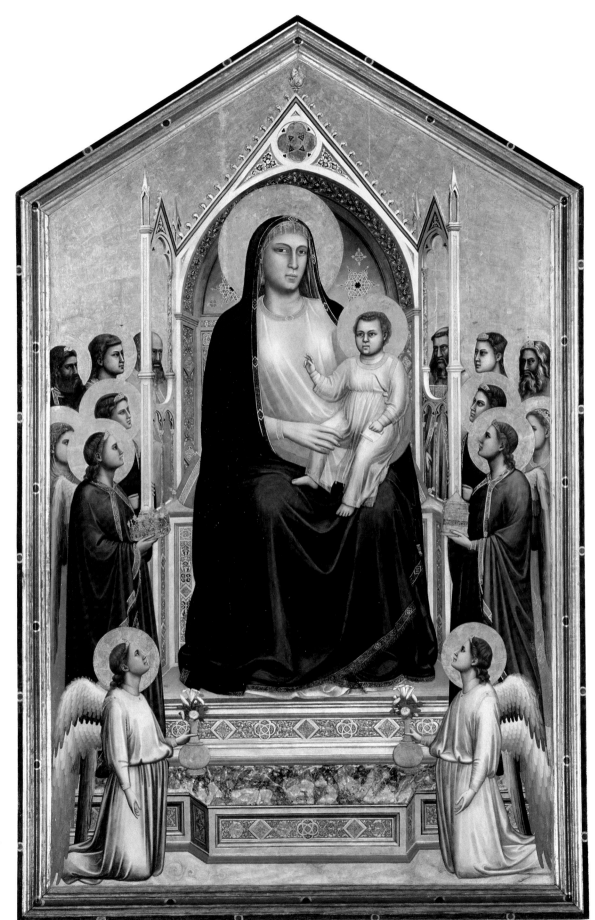

(opposite)
30. Duccio di Buonin-
segna. Detail of the
Madonna and Child in
the *Maestà* (fig. 1)

31. Giotto di Bondone.
Maestà from the Church
of Ognissanti, Florence,
ca. 1306. Gold and
tempera on wood,
10 ft. 8 in. x 6 ft. 8⅜ in.
(3.3 x 2 m). Galleria
degli Uffizi, Florence

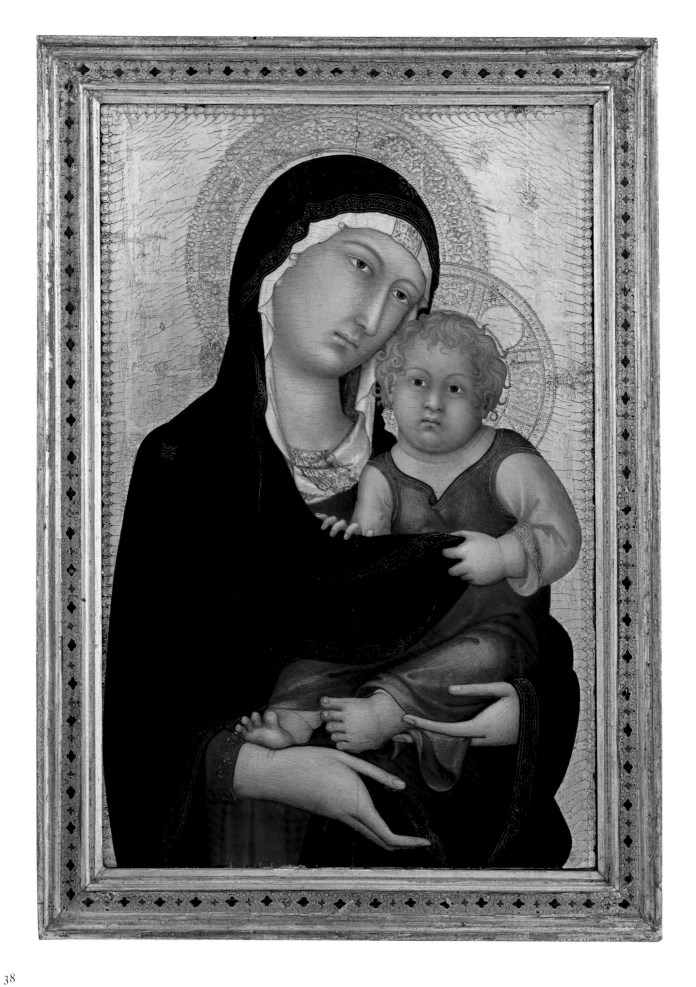

few years of each other, the matter comes into focus. The first thing to note is that Duccio was aware of Giotto's cogent restructuring of pictorial space and that he took full advantage of the innovations of the younger Florentine. As in Giotto's painting, so in the *Maestà* the throne is viewed frontally and displays a logic that was still absent from the *Ruccellai Madonna*. It is conceived not as an elaborate spindle chair but as a mosaic-embellished piece of architecture worthy of the cathedral in which it was installed. (Duccio first experimented with a massive marble throne in the stained glass window he designed for the apse of the cathedral in 1287 [see fig. 5], when the *Ruccellai Madonna* must have been nearing completion, but only in the *Maestà* did he attempt a frontal rather than an oblique point of view.) The angels are no longer stacked or appliquéd at the sides of the throne. Instead, they lean on and over it. This, again, marks Duccio's growing awareness of space as a conditioning factor in painting, a factor that he fully exploited in the narrative scenes of the predella and on the reverse of the altarpiece. The cloth of honor, in all its oriental richness, falls in more naturalistic folds, bunching up at the back of the pillow, and the Child is now the big, healthy eighteen-month-old familiar from later Italian painting. He responds to the viewer's presence with a timid, protective gesture, an idea that Simone Martini later took up and developed in his haunting painting in the Robert Lehman Collection at the Metropolitan (fig. 32). Yet despite the increased emphasis on space, the imagined response to the viewer's presence, and the natural-seeming details such as the damaged but still legible drapery that describes the underlying form of the Virgin's body, those gold striations (known as chrisography) derived from Byzantine practice have been reintroduced in the Madonna's vermilion dress. In art historical terms this would be explained by Duccio's conservatism: his inability to fully liberate himself from the medieval and Byzantine traditions in which he was trained (certainly this is the way Ghiberti and Vasari would have seen the matter). But such an explanation hardly does justice to the expressive effect of the painting or to Duccio's ultimate achievement. Rather, it is as though he felt a need to reassert the sacral, otherworldly quality associated with an older art and to reaffirm that the worshiper is not standing before a grand but perhaps too human woman but is in the presence of the Queen of Heaven—someone who seems to have come from a distant time and place conceived in the mind of God. And then there are Duccio's angels. In few other paintings, if any, does the angelic court of the Virgin have such a mesmerizing effect. These are not Giotto's grave, earthbound creatures, standing or kneeling in dignified attitudes of respect and awed devotion. Duccio has painted figures of pure longing, messengers of love who, to appropriate the incandescent verses of Milton ("On the Morning of Christ's Nativity"), "stand fixt in steadfast gaze, / Bending one way their precious influence, / And will not take their flight, / For all the morning light." They are bearers of "unexpressive notes to Heav'ns newborn heir," their solemn yet tender faces peering over the top of the throne, chins resting gently on the backs of their hands. A sacred quiet pervades the image that no later artist was able to recapture. Is it any wonder that the principal figures were widely imitated? Following Duccio's death his most faithful pupil, Ugolino di Nerio, was asked to paint the main altarpiece for the two principal mendicant orders in Florence: the Franciscans at Santa Croce and the Dominicans at Santa Maria Novella. Thus even in Florence there would seem to have been those who preferred the ineffable quality of Ducciesque delicacy and refinement to Giottesque gravitas.

Many times in history two artists have provided their contemporaries with alternative or complementary visions: Masaccio and Fra Angelico, Jan van Eyck and Rogier van der Weyden, Raphael and Michelangelo, Caravaggio and Annibale Carracci, Rembrandt and Rubens, Ingres and Delacroix, Picasso and Matisse. In a well-known essay of 1897, Bernard Berenson called Duccio a master of composition "so subtle in its effects of mass and line

32. Simone Martini (Italian, ca. 1284–1344). *Madonna and Child*, ca. 1326. Gold and tempera on wood, 23⅛ x 15½ in. (58.7 x 39.4 cm). The Metropolitan Museum of Art, Robert Lehman Collection, 1975 (1975.1.12)

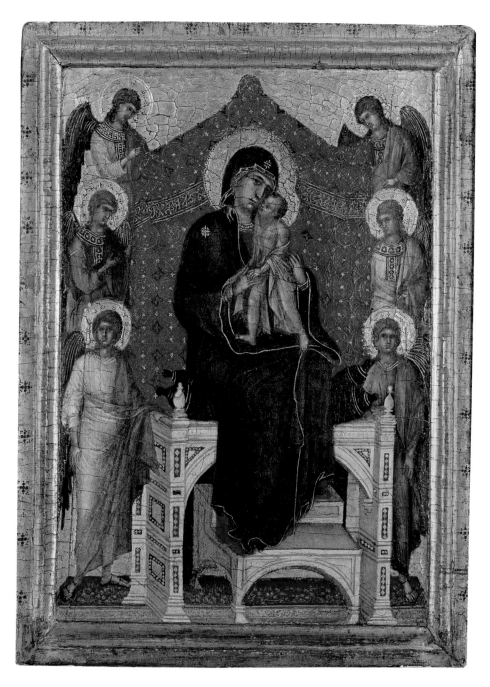

that we shall scarcely find its like." To his mind only Raphael, two centuries later, could rival Duccio in this area. Berenson then went on to contrast Duccio's gifts with Giotto's emphasis on purely formal values, which he felt led ultimately to the work of Michelangelo. Berenson saw Duccio as "a pictorial dramatist, as a Christian Sophocles," and Giotto as the master of "form and movement—the two most essential elements in the figure arts." Laying aside Berenson's somewhat dated aesthetic categories, we might prefer to think of Duccio, with his supreme sense of color and design, as the Matisse of the fourteenth century, but a Matisse who thought of the spiritual almost exclusively in terms of Christian narrative. Together, Duccio and Giotto provided the foundation on which generations of trecento artists built, and it is impossible to do justice to the art of their successors without reference to both.

Between 1285–87, when he painted the *Ruccellai Madonna*, and 1308–11, when the *Maestà* was created, Duccio's art underwent an enormous transformation. No documented paintings fill the gap between those two enormous paintings—the two most important by Duccio to have survived—but a number of small or modestly scaled devotional pictures and the remains of one altarpiece are usually seen as signposts pointing toward the achievement of the *Maestà*. Much the earliest is a ravishing little panel in Bern showing the Madonna and Child enthroned (fig. 33) that was perhaps painted about 1290. In that painting the wood throne of the *Ruccellai Madonna* has already been exchanged for a marble one with real architectural presence, and the Child moves freely across the Virgin's lap. (The way his cheek is pressed against his mother's can be traced to a miraculous Byzantine icon, but the motif was well known in Tuscany and relates to the notion of Christ as the bridegroom of the Virgin/Church.) Although the angels are still stacked up at the sides, their sidelong glances create a new interplay.

For the Church of San Domenico in Perugia, a short distance from Assisi, Duccio painted a now damaged but very beautiful panel (fig. 34) that was once the centerpiece

33. Duccio di Buoninsegna. *Maestà*, ca. 1290. Gold and tempera on wood, 12⅜ x 9⅛ in. (31.5 x 23.2 cm). Kunstmuseum, Bern (G0873)

(opposite)
34. Duccio di Buoninsegna. *Madonna and Child* (center panel from a polyptych), ca. 1304(?). Gold and tempera on wood, 37⅝ x 25⅛ in. (95.5 x 63.8 cm). Galleria Nazionale dell'Umbria, Perugia (29)

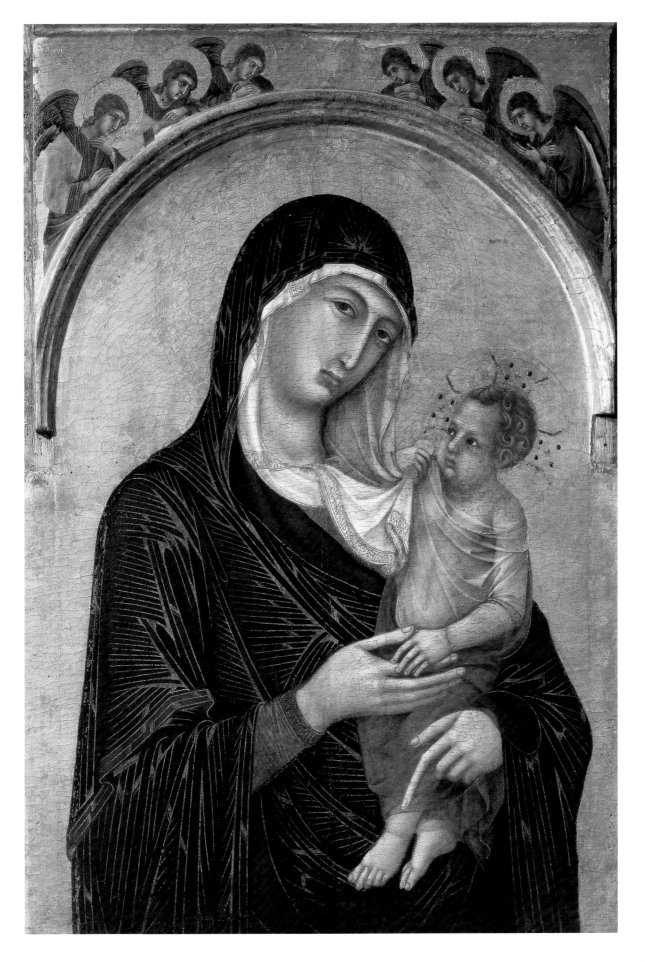

35. Triptych. France, ca. 1300. Ivory, polychromy, and gilding; opened: 9 x 5½ x 1⅛ in. (23 x 14 x 3 cm). The Metropolitan Museum of Art, Gift of J. Pierpont Morgan, 1917 (17.190.279a–e)

36. Duccio di Buoninsegna. *Madonna and Child*, ca. 1295–1300. Gold and tempera on wood, 11 x 8⅛ in. (28 x 20.8 cm). The Metropolitan Museum of Art, Purchase, Rogers Fund, Walter and Leonore Annenberg and The Annenberg Foundation Gift, Lila Acheson Wallace Gift, Annette de la Renta Gift, Harris Brisbane Dick, Fletcher, Louis V. Bell, and Dodge Funds, Joseph Pulitzer Bequest, several members of The Chairman's Council Gifts, Elaine L. Rosenberg and Stephenson Family Foundation Gifts, 2003 Benefit Fund, and other gifts and funds from various donors, 2004 (2004.442)

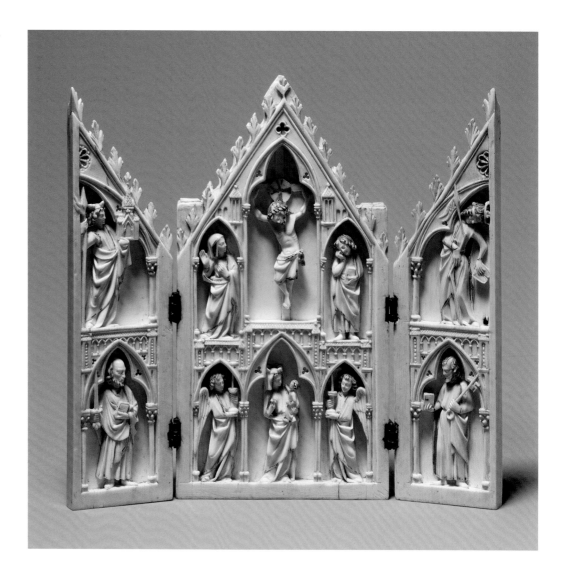

of a Gothic polyptych, probably with a triangular pinnacle and four lateral panels with images of saints. It has been conjectured that the altarpiece was painted about 1304, when the Dominican pope Benedict XI visited the city. In the center panel, Duccio employed the engaging motif of the Child playing with the Virgin's veil. The same idea is occasionally found in French ivories of the period (see fig. 35), but in Duccio's rendering there is no trace of the secular, courtly world that pervades French Gothic art. Instead, he used the seemingly casual motif to give an added human dimension to a devotional image. Mother and child are isolated against the gold background of the arched panel. The Virgin, wearing a blue cloak webbed in gold striations, gazes pensively at the viewer, while the Child, beautifully garbed in a transparent shirt with a wide neckline that exposes his shoulder, is completely absorbed by his mother as he gathers up a portion of her veil. In many respects the picture is a sort of dress rehearsal for the *Maestà*, not least in the way the angels are shown leaning on and over the actual molding of the frame, a play between the pictorial space they inhabit and the three-dimensional molding of the frame that Duccio used to physically extend that pictorial space forward.

Two other works Duccio painted for private devotion are less formal in their treatment of the theme of the Madonna and Child: the small, ravishing panel acquired in 2004 by the Metropolitan Museum (fig. 36) and a triptych in the National Gallery, London (fig. 38). Because documentary evidence is so spotty, the precise chronology of these panels is

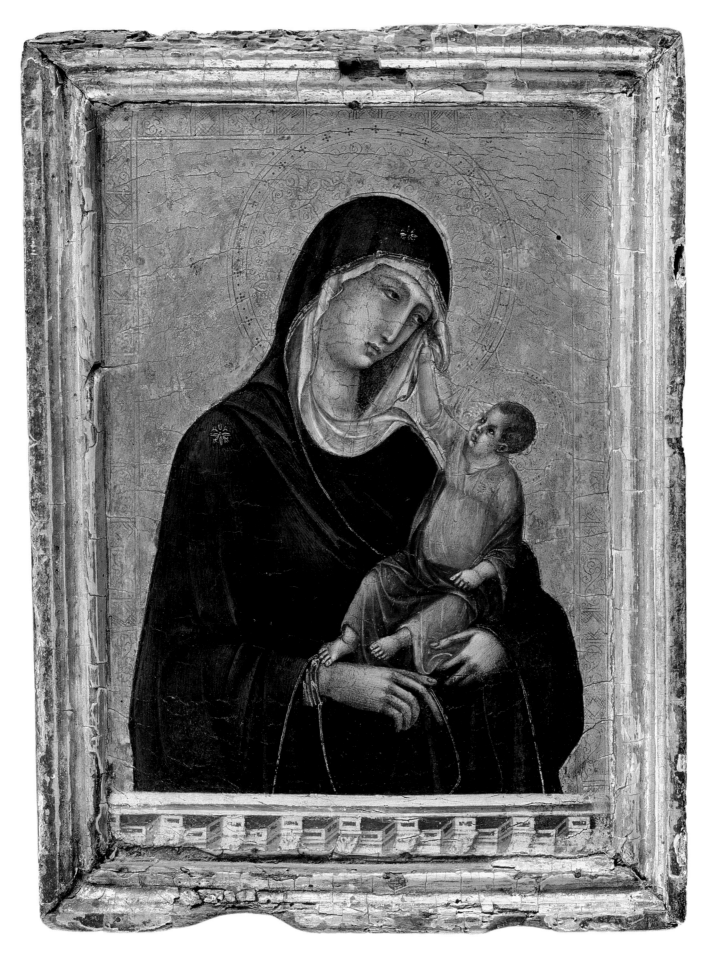

43

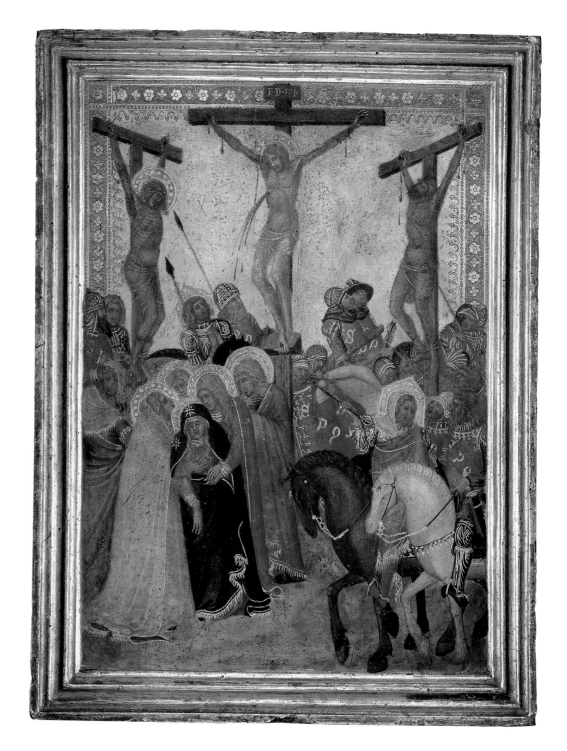

difficult to establish, but the one in the Metropolitan seems to be the earlier of the two and may even date to the late 1290s. The London triptych seems to have been painted sometime after about 1305.

Except in rare cases, tracing the early history of paintings such as these and thus establishing the probable circumstances of their commission is almost impossible. Most paintings of this date are not signed, so unless the name of the artist who painted this or that object was kept alive from generation to generation, it simply died out. There was also a tendency for paintings to be ascribed to the names recorded by Vasari. For instance, the Metropolitan's extraordinary *Crucifixion* by Pietro Lorenzetti (fig. 37) was prized by the nineteenth-century French painter Paul Delaroche as the work of Giotto, although this was merely a

matter of romantic association. Delaroche had made a trip to Italy to study fourteenth-century frescoes prior to undertaking his cycle of murals in the Church of the Madeleine in Paris. (Thanks to one of those frequent shifts in taste, after centuries-long neglect trecento murals had been rediscovered as touchstones of artistic excellence.) In 1834 he stayed at the Tuscan monastery of Camaldoli, where he made some marvelous oil studies of the monks. Delaroche knew his Vasari, and he must have remembered that the sixteenth-century biographer recorded having seen in one of the cells of the monks at Camaldoli "a little Crucifixion with a gold background, by Giotto, that was very beautiful." There can be little doubt that in buying the Pietro Lorenzetti, Delaroche thought—or rather fancied—that he had found the painting Vasari described. Only with the rise of modern art history and the sharpening of their eyes through the study of thirteenth- and fourteenth-century paintings have scholars been able to cut through the thickets of these early, optimistic attributions, which were based more on wishful thinking than on real knowledge of the period.

We will probably never know for whom Duccio painted the panel the Metropolitan acquired. It shows the most common of all subjects in Italian painting and in early inventories would likely have been listed merely as "a small panel of the Madonna and Child," with no name attached to it. Even if we were to find an early inventory with the entry "a small panel of the Madonna and Child, from the hand of Duccio," there would be no basis for thinking we had discovered the early history of our panel: too many pictures have been lost. One possible clue is an inscription penciled in longhand on the reverse that was only uncovered when a modern wood reinforcement, or cradle, was removed following its acquisition by the Metropolitan: ~~Segna~~ *? della Buoninsegna.* The inscription testifies to a confusion between the name of Duccio di Buoninsegna and that of his follower Segna di Buonaventura. Whoever proposed his name and then crossed it out must have had more than common knowledge of Sienese painting, and that "Buoninsegna" was retained can only mean that the writer had Duccio in mind. Unfortunately, the form of the handwriting is such that it could date from the nineteenth or even the early twentieth century.

Only occasionally is it possible to reconstruct, bit by bit, a credible early history of a thirteenth- or fourteenth-century picture, albeit in a highly conjectural fashion. Such is the case with the triptych in the National Gallery, London (fig. 38). One of the two saints on the folding wings is clearly Saint Dominic, the thirteenth-century founder of the Dominican order, and his presence certainly indicates that the first owner was a Dominican or someone whose patron saint was Dominic. The other saint, a woman holding a cross, is identifiable only because there is a partial inscription just above her right shoulder that reads, in abbreviation, *Sancta Aurea.* A third-century martyr, Aurea is rarely represented in art, but she is the patron of Ostia, near Rome, so there is the presumption that whoever commissioned this work also had some connection with that city. In the early fourteenth century the cardinal of Ostia was a high-ranking and cultured Dominican by the name of Niccolò da Prato (ca. 1250–1321). As his name suggests, he was from Prato, in the Arno Valley. He was promoted to cardinal in 1303 and was also papal legate to Florence. In 1304 he attempted to mediate the factional warfare that divided the city and had led to the exile of Dante. Dante and Niccolò da Prato knew each other: a letter Dante addressed to the cardinal has survived. Given his importance and position, that Niccolò da Prato commissioned this picture from Duccio is at least a good possibility, and it may even have been among the "three paintings to put on an altar" that he bequeathed to the Church of San Domenico in his native Prato. If this is so, then we have yet further testimony to Duccio's celebrity in non-Sienese circles, for we might have expected the prelate to turn to Giotto for a devotional image. An extension of the same line of reasoning that led to suggesting Niccolò da Prato as the first owner of the Madonna and Child in London has been

38. Duccio di Buoninsegna. *The Virgin and Child with Saints Dominic and Aurea* (portable triptych), ca. 1305–10. Gold and tempera on wood, center panel: 16¾ x 13⅝ in. (42.5 x 34.5 cm). National Gallery, London (NG566)

extended to an identically constructed triptych in the Museum of Fine Arts, Boston (fig. 39), that includes on its folding wings depictions of Saint Gregory the Great, a father of the Church, and Saint Nicholas of Bari, Niccolò's namesake, but this remains highly speculative.

Although we can assume that the first owner of the Metropolitan's painting was also someone of wealth or social standing—Duccio was entirely too important an artist to bother himself with just anybody—that we will ever know his identity is extremely unlikely. On balance, the picture's first owner was unlikely to have been someone of the rank of Niccolò da Prato, for it is smaller and the composition is more informal; an effect of intimacy is what was desired. That it was a coveted devotional object to which prayers were addressed there can be no doubt, for the bottom edge of the frame has been scorched by unattended candles. Some scholars have conjectured that the picture formed part of a diptych, a common form for devotional paintings of the fourteenth century. But there are no hinge marks along the vertical edges, and holes piercing the back of the panel along the upper edge attest that the picture was hung by an iron ring, perhaps over a bed or a prie-dieu.

The picture's recorded history begins only in 1904, when it was lent to a landmark exhibition of Sienese painting by its owner, the Russian collector Count Grigorij Stroganoff. It was quite a debut. Reviewing the exhibition, F. Mason Perkins, a leading specialist in Sienese painting, wrote, "We find Duccio himself represented by but a single panel. Count Stroganoff's beautiful little Madonna, however, amply compensates us for what we may miss in the matter of mere numbers. . . . It shares with [the small, early painting of the Virgin and Child adored by Monks in the Sienese gallery (fig. 28)] its tenderness of expression, its soft grace of line and colour, and its wonderful miniature-like finish." Mary Logan (the wife of Bernard Berenson) was even more emphatic in her praise, declaring that "the most perfect work is the little Madonna by Duccio that belongs to Count Gregori Stroganoff, . . . which, small though it is, offers so much majesty, dignity and profound sentiment. It is worth all the other pictures exhibited under Duccio's name." From that point on the picture has held a central place in the Duccio literature, even though it was shown publicly on only one other occasion, the great "Exhibition of Italian Art" held at the Royal Academy in London in 1930, and was seen by only a few specialists after that.

What we know about Count Grigorij Stroganoff (1829–1910) is described in an appendix to this essay by Varduì Kalpakcian. Here it is enough to note that the Russian expatriate owned a lavishly decorated house in the Via

Sistina in Rome, where he kept an outstanding collection of ancient sculpture and vases and early Italian paintings. The rooms were decorated in a variety of styles. There were eighteenth-century salons for music and a densely packed room with an inlaid floor and gilt ceiling for the Renaissance ceramics and paintings (see figs. 51, 52), among them evidently the Duccio, which Stroganoff may have purchased sometime in the 1890s—would that we knew from whom.

When he died in 1910, Gregorij Stroganoff left some of his pictures to the State Hermitage Museum in Saint Petersburg, but the bulk of them, including the Duccio, remained locked in his palace in Rome, which his daughter, Princess Maria Gregorievna Scherbatoff, visited only occasionally. Princess Scherbatoff and her son and daughter were killed in Russia in 1920; the widow of Stroganoff's grandson, Elena Petrovna, managed to escape with her two daughters and make her way to Rome. There she found a sympathetic employee at the Russian Embassy who had a key to the palace and let her in. By 1922 the selling of Count Stroganoff's collection had begun. Duccio is a rare artist, and it did not take long for the famous art firm of Duveen to smell a possible purchase. The firm acquired a tapestry and then looked into the collection of ivories as well as a few pictures. In March, Joseph Duveen, urged on by his principal adviser on Italian paintings, the great connoisseur Bernard Berenson (Count Stroganoff was only one of many English and Russian aristocrats Berenson knew), instructed his nephew, Armand Lowengard, whom he had brought into the business four years earlier, to visit the Stroganoff collection. Duveen included in his missive a list itemizing Berenson's recommendations, at the top of which was the Duccio. Lowengard's response came in May: "The pictures, although some of them are quite good and by great masters, are very small and useless to us. The average size of them is about 12 by 10 inches. Besides, the best ones are bequeathed to the Saint Petersburg Museum, and the remainder the lady does not want to sell."

Still in need of money, Elena Petrovna lowered her expectations, and in December 1922 Duveen was advised: "They have offered to sell us any picture. The Duccio is very small and ineffective although extremely rare, price lire 500,000. We consider [that there is] nothing for America." Which certainly meant that Duveen could not imagine many American collectors interested in such small, seemingly recondite works. Subsequently, the asking price dropped further, and in March 1923 this very remarkable report went back to Duveen: "The Duccio is

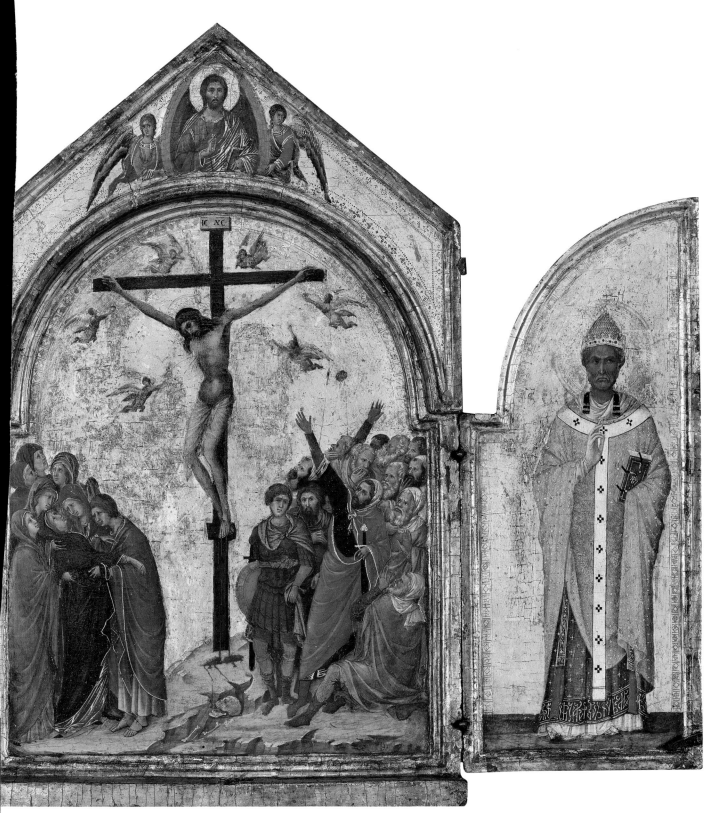

39. Duccio di Buoninsegna and workshop. *The Crucifixion, The Redeemer with Angels, Saint Nicholas, Saint Gregory* (portable triptych), 1305–10. Gold and tempera on wood, center panel: 24 x 15½ in. (61 x 39.4 cm). Museum of Fine Arts, Boston (45.880)

still unsold. . . . The picture is very small, practically colorless, that is to say almost black. The only color is the Virgin's face and her robe which is nearly black. The picture itself is no larger than a small sheet of note paper, but it is the only authentic Duccio in private hands. We mention this to you because they are sure to sell this picture very soon as they want money, and some man like Goldman or Lehman will buy it." Goldman and Lehman were the New York collectors Henry Goldman and Philip Lehman, the father of Robert Lehman. Both were avid collectors of early Italian paintings. (Many of Goldman's finest paintings, including a Madonna and Child by Giotto, were later sold to Samuel H. Kress and are now in the National Gallery of Art in Washington, D.C.) All told, this was about as irresponsible and misleading a report as can be imagined, for the picture was neither lacking in color nor black: quite the contrary. A photograph taken in 1904 and the reviews of the 1904 Siena exhibition make clear that in all essentials the picture looked very much like it does today. So the report must be considered either the product of ignorance or skewed by a profound aesthetic blindness. On March 17 the New York office of Duveen wired the Paris branch: "Not interested [in the] Duccio or ivories which [are] too small [and] unimportant." It was, in any event, too late to make a move, as by November the ivories and the Duccio had been sold to the Roman-based dealer Sangiorgi, who quickly found a buyer for the Duccio.

What good fortune that Duveen did not buy the painting, for he would certainly have put a new frame on it, regilt the background, and made sure that the colors positively glowed! Instead, the painting was acquired by one of the most discerning collectors of early Italian paintings, Adolphe Stoclet (1871–1949), a Belgian banker and industrialist whose wife was the daughter of the painter Alfred Stevens. Stoclet was interested in Middle Eastern antiquities and Asian art as well as early Italian paintings, and during a two-year stay in Vienna he became friends with Josef Hoffmann and members of the Wiener Werkstätte. Having inherited a fortune, in 1904 he returned to Brussels and set about building a lavish new residence, the Palais Stoclet (fig. 53), the masterpiece of Josef Hoffmann. The large mural commissioned from Gustav Klimt for the dining room incorporated gold mosaic, a reminder of the links between gold-ground Italian "primitives" and modernism.

It was in the Palais Stoclet, evidently in Adolphe's study, that Bernard Berenson saw the picture again in 1933. Upon returning to Italy he wrote from Venice to Duveen's right-hand man, Edward Fowles: "Now as for Stoclet, I should deplore his having to sell. If he does sell, I naturally want you to buy. First and foremost the little Duccio 'Madonna' from the Stroganoff collection. It is the very loveliest and yet the most characteristic thing he ever did. I doubt whether a more precious painting of a primitif exists. It is a treasure you should dive for, and let no one snatch it away." Of those in Duveen's firm, Edward Fowles was perhaps most in tune with Berenson's taste (he had visited Berenson frequently). Not surprisingly, however, when the Paris dealer Bacri reexamined the picture three years later he reassured Duveen that it did not meet their standards and was moreover too expensive. So once again the picture escaped the hollanderizing treatment Duveen lavished on his acquisitions. It sank out of sight and was seen by few specialists until 2004, when it was offered for sale by Stoclet's heirs. So inaccessible was it that it was first reproduced in color only in the catalogue of the Duccio exhibition held in Siena in 2003.

Among the group of remarkable pictures by Duccio that have been preserved, the panel in the Metropolitan holds a special place, for in it he redefined the relation between the viewer and the sacred figures of the Madonna and Child by employing the illusionistic motif of a parapet or ledge. The importance of this invention, of which this is the earliest surviving example in Tuscan painting, is difficult to overstate. Fortunately, we are able to reconstruct how Duccio came upon this genial idea of such great consequence. At some

point after 1292 he must have made a trip to
Assisi to study Giotto's newly completed frescoes
in the Upper Basilica of San Francesco, the fame
of which soon asserted itself throughout cen-
tral Italy; he must have visited the basilica again
when he signed the contract for the Perugia
altarpiece and probably also when he delivered
it. Giotto's audacious paintings gave him his first
glimpse of how a carefully constructed, boxlike
space—the type of setting he was to develop
so remarkably in his narrative scenes on the
Maestà—could increase the believability of the
figural action by endowing the setting with a
palpable, physical dimension. But just as impres-
sive was the illusionistic framework that relates
the narrative scenes of the life of Saint Francis to
the architecture of the church (see fig. 40). Each
frescoed scene is flanked by twisted columns
with a cornice on corbels below (fig. 41) and
another projecting cornice above, suggesting
successive views through a continuous arcade.
In other parts of the church the real architec-
ture is imaginatively expanded onto the broad,
flat surface of the wall by means of illusionistic
painting (fig. 42). These novelties were the crucial
steps toward the illusionistic frameworks found
in so many fresco cycles of the fifteenth, six-
teenth, and seventeenth centuries. The illusion-
istic architecture established a new relationship
between the artistic fiction of the narrative, on
the one hand, and the experiential world of the
viewer, on the other. Duccio must have made
sketches of a number of the motifs, because he
introduced Giotto's cornice into his small panel,
foreshortening the projecting corbels so that a
worshiper kneeling in prayer before the picture
would have the ideal view. From such a low
position the simple but majestic silhouette of the
Virgin assumes its full impact. The attempt to in-
corporate into a picture a specific viewing point
is something we are accustomed to associate with
fifteenth-century, post-Brunelleschian works of
art such as Donatello's sublime marble relief of
the Madonna and Child in Berlin (fig. 43), but its
origins can be traced back to Giotto and Duccio.
The Virgin's effect as a numinous presence is also
greatly increased by the parapet, for this illusion-
istic device both distinguishes our physical world
from the fictive, sacred, gilt world of the Madonna

40. Giotto. *Saint Francis of Assisi Preaching to the Birds*, 1288–92. Fresco. Upper
Basilica, San Francesco, Assisi

41. Detail of cornice in fig. 40

42. Giotto and workshop. *Scenes from the Life of Saint Francis*, 1288–92. Fresco. Nave, north wall, second bay from the west. Upper Basilica, San Francesco, Assisi

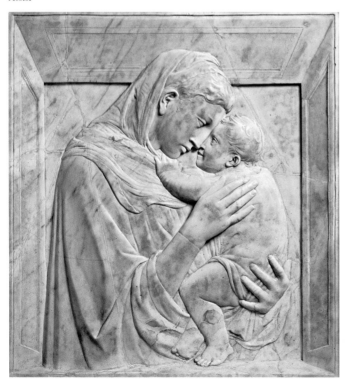

43. Donatello (Italian, ca. 1368–1466). *Madonna and Child (The Pazzi Madonna)*, ca. 1420. Marble, 29⅜ x 27⅜ in. (74.5 x 69.5 cm). Skulpturensammlung und Museum für Byzantinische Kunst, Staatliche Museen zu Berlin

and connects the two. Though she communicates directly with us, it is from the other side of the parapet, so to speak: she clearly belongs to another world. In this little picture Duccio explored, evidently for the first time, what was to become the imaginative realm of Renaissance painting, playing his own artistic vision off against the viewer's experience of the everyday world. Among the painters of the next generation who responded to his innovation was Simone Martini, in a panel that once formed the wing of a diptych or triptych and that shows the grieving figure of Saint John the Evangelist behind a parapet on which is inscribed the date 1320 (fig. 44). In another remarkable, lunette-shaped panel in the Metropolitan Museum that was possibly painted to decorate a niche above a tomb (fig. 45), Giovanni da Milano showed two diminutive donors kneeling on the upper surface of a parapet or ledge, fictively admitting them into the sacred realm of the Virgin (indeed, the Christ Child clasps the prayerful hands of the male donor). In such pictures, painters explored the new expressive and illusionistic possibilities of painting and prepared the ground for a work such as Giovanni Bellini's marvelous *Madonna and Child* in the Metropolitan (fig. 46).

It is with such things in mind that we should understand the extraordinary drapery in Duccio's picture. Like the blue drapery in the *Ruccellai Madonna* (fig. 26), the robes of the Metropolitan's Madonna were painted with very high-grade azurite and are well preserved. Though her garments are undoubtedly somewhat darker than they originally appeared—they probably never had the extravagant richness of the blues in the National Gallery triptych (fig. 38), which are ultramarine, a pigment made from ground lapis lazuli—the modeling is both effective and sculptural. In the National Gallery triptych, Duccio employed the unusual technique of painting the entire area of the Virgin's cloak a uniform blue and then minimally modeling the shadows in a blackish pigment, which he seems to have covered with a red lake glaze (of which only microscopic traces remain), so that almost the entire expanse of blue remained untouched. This emphasized the picture as a precious object, but with a sacrifice of three-dimensionality. In the Metropolitan's picture, by contrast, Duccio sought to create an effect of the Virgin's physical presence, and to achieve this he emphasized the underlying forms of her body. Niccolò da Prato, or whoever was the patron of the National Gallery triptych, must have instructed

Duccio to spare no expense, and especially to use the finest blue available. Paradoxically, less prestigious commissions sometimes allowed early Renaissance artists to explore certain themes and ideas in a more personal way, perhaps less encumbered by tradition or the tastes of a patron. This seems to have been the case with the Metropolitan's painting, which has an impact out of all proportion to its small size.

That the Metropolitan's painting marks a moment of rare equilibrium in Duccio's art is made clear when the studied simplicity of the drapery of the Virgin and the Christ Child is compared with the decorative elaboration in the National Gallery's panel. Indeed, the way the blue cloak subtly describes the underlying form of the Virgin suggests that Duccio may have been inspired by a sculptural source. All the same, the work of the greatest contemporary sculptor, Giovanni Pisano, provides no analogy (see fig. 47). Rather, the drapery of the Metropolitan's Madonna is closer to the example of Giovanni's father, Nicola, who revived the forms of ancient Roman sculpture (see fig. 48). Here too, Duccio may have been following the lead of Giotto and the idea of an artistic revival based on the achievement of ancient art.

Like the art of Giotto, Duccio's painting also adheres to the literary ideals of the *dolce stile nuovo* (sweet new style) spearheaded by Dante and his friend and fellow poet Guido Cavalcanti—a poetry

44. Simone Martini. *Saint John the Evangelist*, 1320. Gold and tempera on wood, 13⅝ x 9½ in. (34.5 x 24 cm). Barber Institute of Fine Arts, University of Birmingham

45. Giovanni da Milano (Italian, active 1346–69). *Madonna and Child with Donors*, ca. 1365. Gold and tempera on wood, 27⅛ x 56¾ in. (68.9 x 144.1 cm). The Metropolitan Museum of Art, Rogers Fund, 1907 (07.200)

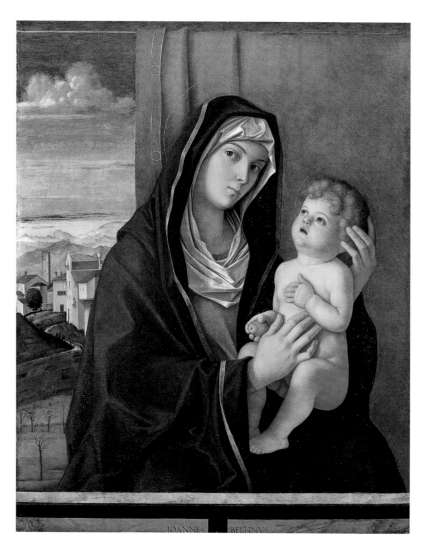

46. Giovanni Bellini (Italian, active by 1459, died 1516). *Madonna and Child*, probably late 1480s. Oil on wood, 35 x 28 in. (88.9 x 71.1 cm). The Metropolitan Museum of Art, Rogers Fund, 1908 (08.183.1)

devoted to the praise of women and love. In his poem to his beloved, "So Gentle and So Virtuous She Appears," Dante could well have been describing one of Duccio's Madonnas:

*She appears to be a creature who has come
From heaven to earth to show forth a miracle.
She shows herself so pleasing to her beholders,
That she gives through the eyes a sweetness
 to the heart,
Which no one can understand who does not
 feel it;
And it appears that from her lip moves a
 tender spirit full of love,
Which says again and again to the soul:
 "Sigh."*

An even closer, and far more appropriate, analogy for the remarkable style Duccio created is in *The Divine Comedy*, where the theological concepts of Hell, Purgatory, and Heaven acquire an almost physical reality. Dante accomplished this extraordinary feat by populating each realm with people he knew in real life, including, as we have seen, Cimabue and Giotto. Though he was writing a learned poem on the model of Virgil's *Aeneid*, he wrote in Italian instead of Latin, interspersing his verses with colloquial-sounding phrases that break through the formal rhetoric associated with epic poetry. The great literary critic Erich Auerbach encapsulated his achievement: "There were great poets among [Dante's predecessors]. But, compared with theirs, his style is so immeasurably richer in directness, vigor, and subtlety, he knows and uses such an immeasurably greater stock of forms, he expresses the most varied phenomena and subjects with such immeasurably superior assurance and firmness, that we come to the conclusion that this man used his language to discover the world anew."

Part of Dante's technique was a compelling use of similes and analogies. In the fifteenth canto of *The Inferno*, for example, he describes his encounter with two damned souls: "We saw some souls who walked along the bank and stared at us, just as, at evening, when the moon is new, men will stare at one another and will squint, like aging tailors threading needles' eyes." And in the thirty-first canto of *The Paradiso*, he envisions heaven and the mystical rose at its center: "Just like a swarm of bees that, at one moment, enters the flowers and, at another, turns back to that labor which yields such sweet savor, [so the host of angels] descended into that vast flower graced with many petals, then again rose up to the eternal dwelling of its love." The metaphor remarkably suits the minuscule angels who hover "like a swarm of bees" around the Virgin in the National Gallery triptych, one with his hands clasped in prayer, another with them crossed on his breast in adoration, and two swinging perfumed censers.

47. Giovanni Pisano (Italian, ca. 1245/50–before end 1319). *Madonna and Child*, ca. 1312. Marble, h. 27⅛ in. (69 cm). Duomo, Prato

48. Nicola Pisano (Italian, ca. 1220/25–before 1284). Madonna and Child on the pulpit, 1265–68. Marble. Duomo, Siena

Like the writing of Dante, so the art of Duccio and Giotto shifts constantly between an abstracting impulse used to signify a sacred past and details observed from life that register with the shock of the familiar. In the Metropolitan's magical picture, it is the gesture of the Child reaching up to push aside his mother's veil so that he can see her that strikes a chord so familiar as to make this image register as real. Yet the whole conception of the picture as a miraculous appearance—at once near and distant—and the expression of the Virgin, touched by a sadness that seems to come from another realm, reminds us that we are privileged viewers of a sacred, timeless world. That neither figure acknowledges our presence only increases this effect.

To choose a favorite among Duccio's paintings in Perugia, New York, and London would be no easy task, for each picture has its particular emotional temperature and qualities. Some might choose the sweet melancholy of the Virgin and the loving curiosity of the angels of the Perugia panel. Others will certainly prefer the formal beauty of the Madonna and Child of the London triptych, with the richly articulated silhouette of the figures and the rhythmically arranged folds of the Virgin's veil held by the Child, a passage of painting that Leonardo da Vinci might have envied. Yet in neither of these images do the figures convey that quality of vulnerability and lyrical tenderness found in the New York painting—a work that impresses itself upon our imagination as the private revelation of a supremely great artist and that in so many ways looks ahead to the miracle of the *Maestà*.

Appendix: Duccio's *Madonna and Child* and the Collection of Count Grigorij Sergeevich Stroganoff

Varduì Kalpakcian

Count Grigorij Sergeevich Stroganoff (1829–1910; fig. 49) probably acquired Duccio's *Madonna and Child* (fig. 36) toward the end of the 1890s. He was particularly keen on Italian painting of the trecento and quattrocento and with the help of some of the most outstanding scholars of the time had put together a first-rate selection, the most important of which appeared in a lavish catalogue published after his death.[1] (The Duccio opens the second volume, dedicated to objects from the Middle Ages onward.)[2] According to one close acquaintance, the count "received his friends, but most often scholars and art lovers . . . such as Liphart, Cavalcaselle, Morelli, Lenbach; his favorite guests became Müntz, Furtwängler, Bode, Frizzoni, Berenson, Duchesne, Kondakoff."[3]

One unverifiable source relates that Count Stroganoff noticed the Duccio in a Tuscan antique store, recognized its authorship, and carefully followed its restoration. The first certain notice of the picture, however, was in 1904, when the count proposed lending it, along with a Virgin Annunciate by Simone Martini (now in the State Hermitage Museum, Saint Petersburg), to the "Mostra d'arte antica senese," the great compendium of Sienese art held in the Palazzo Pubblico in Siena that year. Because the offer of the loan was made only eight days before the opening, the book published for the inauguration of the exhibition does not mention either picture.[4] The circumstances are explained in a letter sent in April 1904 to Corrado Ricci, the organizer and main curator of the exhibition: "Now there is here in Florence a likeable and intelligent collector from Rome, Count Gregorio Stroganoff. He has brought with him two little pictures from his famous gallery—one by Simone Martini and one by Duccio. He would like to exhibit them here in Siena. What should he do? And in what way?"[5] The pictures were both accepted, and in the catalogue published

49. Olga Vladimirovna Barjatinskij (Russian, 1865–1932). *Count Grigorij Sergeevich Stroganoff in the Main Atrium of the Palazzo Stroganoff, Rome*, 1902. Oil on wood, 18⅞ x 16 in. (48 x 40.5 cm). Museo di Roma, Rome (MR 7112). Princess Barjatinskij was a relative of Count Stroganoff's and lived for long periods in his Roman palace.

two months later Count Stroganoff is listed as the lender of number 37 (1960), *Madonna col Bambino*, by Duccio, and number 38 (1959), *Madonna Annunziata,* by Simone Martini.[6] The Duccio is described as "the Virgin with Child. He raises her veil with his hand. Duccio di Buoninsegna. XIV cent. Dim. 0,28 x 0,21. Exhibitor Count Gregorio Stroganoff, Rome."[7] As E. M. Stella remarked at the time, "these two pictures, . . . the property of a Russian collector resident in Rome, until then unknown to the scholars, became without any doubt the most important revelation of the pictorial section of the exhibition."[8]

Almost immediately Duccio's *Madonna and Child* was recognized as occupying a very important place in his career. The leading specialist of the day, F. Mason

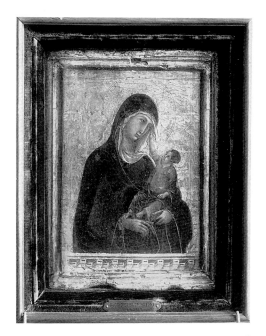

50. "Duccio di Buoninsegna—Prop. Conte Stroganoff Fot. Burton." Photograph of Duccio's *Madonna and Child* (fig. 36) published by F. Mason Perkins in "La pittura alla Mostra d'arte antica in Siena," *Rassegna d'arte* 4, no. 10 (October 1904)

51. Fedor Petrovich Reyman (Russian, 1842–1920). *Study in the Palazzo Stroganoff, Rome, Left Side*, 1905–10. Watercolor. By the kind permission of Orsola di Serego Alighieri Scherbatoff

Perkins, published an article dedicated to the exhibition in which he wrote: "Passing then to the first, without any doubt, great personality of the artistic history of Siena, to the very founder of its pictorial school, Duccio di Buoninsegna, we can see here three pictures with his name: one little *Madonna and Child* (1960), the property of Count Stroganoff, and two others (379 and 380), from Santa Cecilia in Crevole. Of these three panels only the first one can pretend to be the product of Duccio's hand, and, indeed, to be one of the most precious of his paintings, even if the less known."[9]

For a number of years scholarly knowledge of the painting was based on two photographs made in 1904. One was by the Fotostudio Danesi in Rome, which carried out the photographic campaign for the catalogue of the count's collection that was published in 1911–12. The other photograph, signed *Foto Burton,* was published by Mason Perkins in 1904 (fig. 50).[10] These photographs proved to be crucial to scholars, as the painting eventually became all but inaccessible. Indeed, less than a decade later, at another exhibition on Duccio and his school held in Siena, the Burton photograph stood in for the painting, the loan of which proved impossible to obtain.[11]

After the 1904 exhibition the Duccio was returned to the Stroganoff palace at 59, Via Sistina, in Rome. Where precisely it was displayed is not altogether clear, despite the evidence of eleven incredibly detailed watercolors of the palace interior that Russian artist Fedor Petrovich Reyman (1842–1920) executed between 1905 and 1910.[12] Some rare testimonies of the count's contemporaries have also survived. Antonio Muñoz, a close

52. Fedor Reyman. *Study in the Palazzo Stroganoff, Rome, Right Side*, 1909. Watercolor. By the kind permission of Orsola di Serego Alighieri Scherbatoff

53. Josef Hoffmann (Austrian, 1870–1956). Palais Stoclet, Brussels

collaborator in the count's last years who knew both the palace and the collection, noted that the *fonds d'or* (gold ground) paintings—the favorites of the owner—were divided between one of the two drawing rooms at the top of the main stairway and the study on the last floor of the palace.[13] In the commemorative article he wrote in 1910, immediately after the death of Count Stroganoff, Muñoz said clearly that Duccio's little masterpiece was displayed in the study, where the count devoted many hours to his studies and his most beloved masterpieces: "Among the pictures of the Italian school that decorated the study, the one that dominated was the little *Madonna* from the brush of Duccio di Buoninsegna, which, together with the *Virgin Annunciate* by Simone Martini, also from the count's collection, was one of the pearls of the Mostra d'arte antica senese in 1904; this image is full of sweetness."[14] It is not possible to identify all of the pictures in Reyman's two watercolors of the study (figs. 51, 52). But according to Muñoz's testimony the picture was given a prominent place, and it may be the little picture on a wooden support on the left part of the table by the wall with the Brussels tapestry (see fig. 51). Both the dimensions and the proportions correspond. Moreover, as the picture on the right side of the table represents the Madonna and Child (by an unknown painter), it is logical to suppose that its pendant on the left did as well.[15] Then too, the black frame in the photograph published in Mason Perkins's article (see fig. 50) is identical to the one represented in Reyman's watercolor.[16]

Count Stroganoff died in 1910, leaving no detailed legal documents regarding his collection. Nevertheless, his daughter, Princess Maria Gregorievna Scherbatoff, and her children, Prince Vladimir Alekseevich and Princess Aleksandra Alekseevna Scherbatoff, to whom Princess Scherbatoff had ceded all hereditary rights,[17] saw to it that the count's intentions were carried out.[18] In the archives of the State Hermitage Museum in Saint Petersburg is a letter from Count Stroganoff's grandchildren dated July 1911 and addressed to the museum's director, Count D. I. Tolstoy: "Based on what we, and our mother, have known from the persons who have had occasion to speak with our grandfather, . . . we have arrived at the conclusion that he intended to bequeath to the Imperial Hermitage some masterpieces by painters who preceded Raphael. From these we, together with our mother, have decided to give the tabernacle by Beato Angelico, a most interesting example of that epoch, and, from the school of Siena, the *Virgin Annunciate* by Simone Martini. Additionally, we intend to make a further selection of pictures during our next visit to Rome."[19] In 1911 and 1912 Princess Scherbatoff gave the Hermitage two further pictures from her father's collection.

The family of Princess Scherbatoff lived most of the year in Russia and Ukraine and did not stay in Rome for long periods.[20] This proved ill fated, for the Russian Revolution broke out in 1917, and in 1920 Princess Scherbatoff was killed by the Bolsheviks at Nemirov, her estate in Ukraine, together with her son and daughter. The following year the widow of Prince Vladimir Scherbatoff, Elena Petrovna (née Stolipyn), escaped from Russia and succeeded in reaching Rome with her two little daughters, Olga (born 1915) and Maria (born 1916). Countess Maria Vladimirovna Scherbatoff di Serego Alighieri recalls that the keys of the Palazzo Stroganoff were brought to her mother by a functionary of the former Russian Empire's embassy.[21] As the family had no means of support, the contents of the palace provided their finances. In 1923 Princess Scherbatoff married Prince Vadim Grigorievich Wolkonsky, designating him as the tutor of her underage daughters (the actual

heirs of the late Count Stroganoff). Most of the sales took place in the following few years, and in 1926 Roberto Longhi proclaimed, "The dispersion of the Stroganoff Collection is by now an accomplished fact."[22]

Longhi angrily denounced the circumstances of this dispersion and the exportation from Italy of some of the most famous pieces of the Stroganoff collection. The Roman antique dealer Giuseppe Sangiorgi and the British-based firm of Duveen were among the primary purchasers. Sangiorgi acquired paintings (including the Duccio), sculpture, and applied arts of different epochs, while Duveen bought a unique sixteenth-century tapestry of Brussels manufacture.[23] The sale and export of the Duccio *Madonna and Child*, in particular, filled Longhi with indignation. Countess Maria Vladimirovna Scherbatoff di Serego Alighieri, who was ten years old in 1926, recalls that the little picture by Duccio was sold for "4 thousand pounds." She is not sure of the number but has no doubt about the type of currency. Within a few years the painting had been acquired by the Belgian industrialist, banker, and collector Adolphe Stoclet, and it would remain in the Palais Stoclet in Brussels (fig. 53) until its purchase by The Metropolitan Museum of Art in 2004.

1. Antonio Muñoz, *Pièces de choix de la collection du compte Grégoire Stroganoff à Rome*. 2 vols. (Rome, 1911–12).

2. Ibid., vol. 2, p. 9, pl. 1.

3. Antonio Muñoz, "La collezione Stroganoff," *Rassegna contemporanea* 3, no. 10 (October 1910), p. 9.

4. Corrado Ricci, *Il Palazzo Pubblico di Siena e la Mostra d'antica arte senese* (Bergamo, 1904).

5. C. Placci to Corrado Ricci, April 9, 1904 (Biblioteca Classense, Ravenna, Carteggio Ricci, Arte Senese, Mostra 1904, vol. 1, doc. 56), cited in E. M. Stella, "Cronache da Siena: La Mostra d'antica arte senese del 1904," *Ricerche di storia dell'arte* 73 (2001), p. 15.

6. *Mostra dell'antica arte senese, aprile–agosto 1904: Catalogo generale illustrato*, exh. cat., Palazzo Pubblico (Siena, 1904), p. 368.

7. Ibid., p. 308.

8. Stella, "Cronache da Siena," p. 15.

9. F. Mason Perkins, "La pittura alla Mostra d'arte antica in Siena (con dodici incisioni)," *Rassegna d'arte* 4, no. 10 (October 1904), p. 145.

10. Ibid.

11. *Mostra di opere di Duccio di Buoninsegna e della sua scuola*, exh. cat., Museo dell'Opera del Duomo (Siena, 1912), p. 40.

12. See Varduì Kalpakcian, "Il palazzo romano del conte G. S. Stroganoff negli acquarelli di F. P. Reyman," *Pinakotheke*, nos. 16–17 (2003), pp. 184–95. Reyman's watercolors (now in a private collection in Rome) are especially notable for their thoroughness and precision; P. V. Khoroshilov has suggested that they were done from photographs. Fedor Reyman moved to Rome from Saint Petersburg in 1869 and from 1880 worked as a copyist of epigraphic monuments and early Christian frescoes in the Roman catacombs.

13. Antonio Muñoz, *Figure romane* (Rome, 1944), p. 143: "From the antechamber on the ground floor one passed to the main stairway in the Louis XVI style . . . that led to the library with walls covered with wardrobes of the XVIth century from the sacristy of a monastery in Viterbo. In front, in the noble antechamber, were displayed the Italian 'primitives.'"

14. Muñoz, "Collezione Stroganoff," p. 5.

15. The great-granddaughter of Count G. S. Stroganoff, Countess Maria Vladimirovna Scherbatoff di Serego Alighieri, who lived in Palazzo Stroganoff from 1921

until 1930 (i.e., from five to fourteen years of age), recalls that on this table, near the tapestry, there were two little pictures, both of the Madonna and Child.

16. Mason Perkins, "Pittura alla Mostre," p. 145.

17. V. A. and A. A. Scherbatoff to Count D. I. Tolstoy, director of the Imperial Hermitage, July 10, 1911 (Archives, State Hermitage Museum, f. 1, op. v, 1911, d. 36, fol. 33).

18. Muñoz (*Figure romane*, p. 149) reported that "according to the decision of the count's daughter, Princess Scherbatoff, the preparation of the catalogue continued as established by the count himself, and the sumptuous publication, in two richly illustrated volumes, was published the following year. Trusting my report of the count's wishes, the princess gave to the Hermitage a group of the silver Sasanian vessels, a Byzantine reliquary chest, the tabernacle by Fra Angelico, and to the Galleria Nazionale in Rome was given the *Portrait of Erasmus of Rotterdam* by Quentin Metsys." On the donations to the museums by the Scherbatoff family in 1911–12, see Ludwig Pollak, *Römische Memoiren: Künstler, Kunstliebhaber und Gelehrte 1893–1943* (Rome, 1994), pp. 227–29; and N. Makarenko, "Neskol'ko predmetov iz sobraniia grafa G. S. Stroganova (dar kn. M. G. Shcherbatovoi Imperatorskomu Ėrmitazhu" (Some objects from the collection of Count G. S. Stroganoff [gift of Princess M. G. Scherbatoff to the Imperial Hermitage]), *Starye gody*, October 1911, pp. 34–49.

19. See note 17 above.

20. Pollak, *Römische Memoiren*, p. 228: "Princess Scherbatoff, with her charming daughter and her son, remained for some time in Rome in 1911, but then went back to Russia. She never returned to Rome till the beginning of the war, and naturally, neither did later."

21. A year later, in 1922, Mussolini's party assumed power and in 1924 his government recognized Soviet Russia. The Soviet embassy opened in Rome and "nationalized" all the real and personal property of former Russian citizens.

22. Roberto Longhi, "Commenti," *Dedalo* 4, no. 2 (1925–26), p. 479.

23. Muñoz, *Pièces de choix*, vol. 2, pp. 53–54, pls. 36–38.

Bibliographic Notes

Auerbach, Erich. *Mimesis: The Representation of Reality in Western Literature.* Translated by Willard Trask. 50th Anniversary ed. Princeton, 2003.

Bagnoli, Alessandro, Roberto Bartalini, Luciano Bellosi, and Michel Laclotte. *Duccio: Siena fra tradizione bizantina e mondo gottico.* Siena, 2003.

Belting, Hans. *Likeness and Presence: A History of the Image before the Era of Art.* Translated by Edmund Jephcott. Chicago, 1994.

Christiansen, Keith. "The Metropolitan's Duccio." *Apollo Magazine* 165, no. 540 (February 2007), pp. 40–47.

Dante Alighieri. *Inferno.* Translated by Elio Zappulla. New York, 1999.

———. *Paradiso.* Translated by Allen Mandelbaum. Toronto, 1986; reissued New York, 2004.

Norman, Diana, ed. *Siena, Florence, and Padua: Art, Society, and Religion, 1280–1400.* 2 vols. New Haven, 1995.

Satkowski, Jane Immler; edited by Hayden B. J. Maginnis. *Duccio di Buoninsegna: The Documents and Early Sources.* Athens, Ga.: Georgia Museum of Art, 2000.

Schmidt, Victor M. *Painted Piety: Panel Paintings for Personal Devotion in Tuscany, 1250–1400.* Florence, 2005.

Stubblebine, James H. *Duccio di Buoninsegna and His School.* 2 vols. Princeton, 1979.

White, John. *Duccio: Tuscan Art and the Medieval Workshop.* London, 1979.

Photograph Credits and Copyright Notices